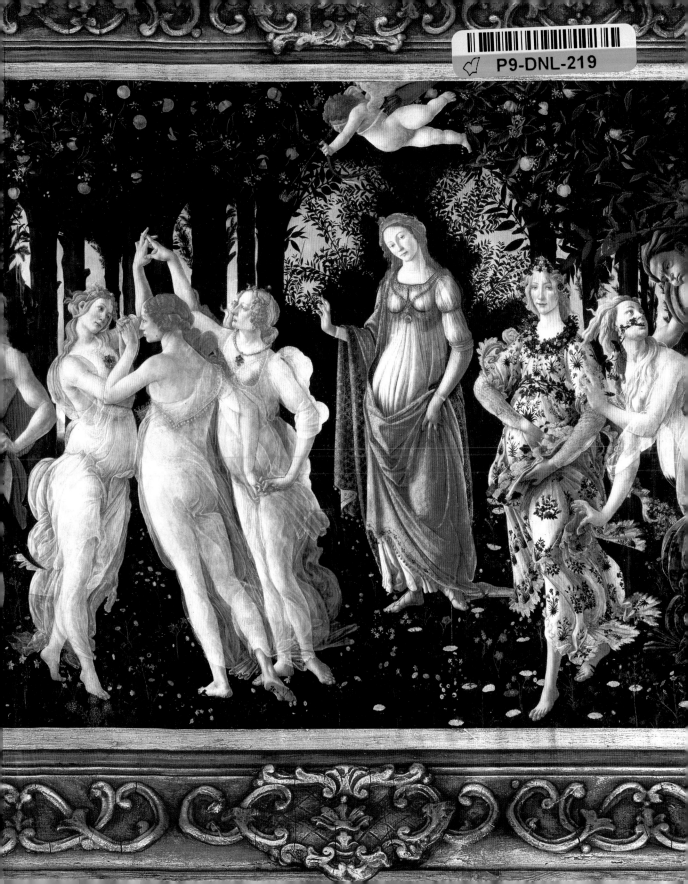

CONTENTS

INTRODUCTION

Master Pieces is a new version of a classic art curator's game. I was introduced to it when I joined the staff of The Metropolitan Museum of Art. Once a week, at morning coffee break (which was delightfully long in the museum world), a different curator would bring a bunch of photographs of details taken from works in the collections. The players would then try to match the details to the appropriate work. Two details for each work were included: an exceedingly difficult one and an easier one. You always got a verbal hint, too, which helped a lot. The person who won got free coffee for the week.

How did the game come about? It was first proposed by a Met photographer who had heard curators discuss how vital details were in assessing the quality, authenticity, and importance of any work of art. He also knew that curators write exhaustively detailed descriptions of any piece being considered for possible purchase; this helps them to understand each piece fully. Curators' work is all about looking—intently, intensely, constantly, again and again, from the overall work to all its details and back again. The essence of the investigation of style—that complicated signature of every artist, period, and civilization—is scrutinizing the details.

Over the years I remember some ridiculously easy details that we all got immediately—such as the man on the dismasted boat in Winslow Homer's unforgettable *Gulf Stream* (see page 147). And I recall some that only few of us spotted. For example, there was one detail of a shining splotch of black and gold that everyone thought was some of the dripped paint from Jackson Pollock's *Autumn Rhythm.* Wrong. The winner smugly told us that it was a part of the thick golden chain around the neck of Aristotle in Rembrandt van Rijn's world-famous *Aristotle Contemplating the Bust of Homer,* painted in the seventeenth century.

My finest moment in the curator's game was picking out, in seconds, the fuzzy left ear of the huge dog at the feet of the family in Renoir's portrait *Madame Charpentier and Her Children.* We were all defeated by a stunning pair of Egyptian yellow-green chalcedony lips; the detail and the whole were one and the same—all that has survived of what must have been the portrait of the ages. I played and used the game in all my positions at the Met, from curator of the medieval collections and of the Cloisters to director of the museum.

I am delighted to share this game with the world. I can't think of a more intellectual, educational way to pass the time. And the fact that the game is great fun—what is more fun than finding the answer to a puzzle, especially if you can do it before anyone else?—is an added bonus.

To play our Master Pieces game, you don't have to be a curator with advanced degrees or years of experience. No matter what your expertise or how you play the game, some details will take seconds to find; others may take—well—months. Or, perhaps, there are one or two you'll never find. (We have to be cruel at times, so you'll respect the challenge. But take heart, there's a key to which painting each detail belongs on page 176.)

Master Pieces is divided into two sections. In the front you'll find the details—some are grouped according to categories, such as hands, eyes, faces, musical instruments; others stand alone. After the details you'll find our gallery, the fifty-seven paintings from which the details have been taken. The pages in the gallery are cream-colored, so you'll be able to find this section quickly. The paintings we've chosen date from the thirteenth century to the modern day, but we've made no attempt to provide an overview of art history. We've chosen some paintings because they are famous, some because

they are not, and some simply because they are a fabulous universe of details, such as *Allegory of Sight* by Jan "Velvet" Brueghel. Each painting in the gallery is accompanied by a brief biography of the artist and some salient facts about the picture.

Some of the details we've chosen are so grand that they'd stand on their own as masterpieces—like the vase of lilies from Hugo van der Goes's *Portinari Altarpiece* or the carafe in Caravaggio's *Bacchus*. Other details are tiny barely recognizable images, like a tree from a complicated landscape, small folds of fabric, or a hand or pair of eyes. Each detail is accompanied by at least one written clue. In general they relate to the style of the work or its artist or its overall tone. Some of the clues are straightforward; others can be tricky. Some refer to information in our essays; others do not. If you read the clues carefully, you'll garner at least a nugget of useful information.

All it takes to track down many of the details is a keen inquiring eye and a passing acquaintance with the history of art. But be warned: As the details unfold they get progressively harder. Still, we've stowed a few easy ones in the last few pages, too— and a few tough ones right up front as well, for initial challenges.

We've marked the hardest details—those that are barely recognizable to the naked eye or that come from more obscure paintings—with red diamonds like this: ◆◆. Not all of the details appear in the same direction as they do in the painting—some are upside down or sideways, so don't take anything for granted. Finally, on page 176 there's always that answer key.

◆◆◆

There are several ways to play:

◆ **RECOGNITION:** Browse through the details and see how many you recognize immediately; confirm your answers by finding the details in the full work.

◆ **INFORMATION:** You can also play by using only the written clues to identify the painting to which a detail belongs. You'll note that some of the clues

are deliberately cryptic. You'll have to pull together all the art history in your head to find the answer. Remember that the clues usually refer to the style, the artist's life, or the feeling of the work.

◆ **EXAMINATION:** For a detail you cannot spot at once, after familiarizing yourself with it, search through all the paintings in the gallery section to match it. This is the most rewarding method, because poring over the paintings is the best way to really get to know them. Plus, it's most like the original curator's game and a curator's work habits.

For example, take detail 1, three dancing women. The first clue tells you that the artist set a standard for beauty; you might immediately know which artist is known for beautiful women. The rest of the clue tells you that the artist worked several hundred years ago; and the next one tells you that he lived in Florence. So you have a rough time period and a place; look at the paintings from Renaissance Italy and you'll find it quickly. Let your mind wander over the last clue—think Vivaldi and pasta—and you'll eventually think of Vivaldi's best-known work, *The Four Seasons*, which might remind you of pasta primavera, and you've got the title of the work—Botticelli's *Primavera*.

◆ **COMPETITION:** Play with another "curator" or a group. As you go from one detail to the next, award two points, say, for each one recognized before the clues are read, one point if they're recognized after the clues are read. Double the points for the "red diamond" clues.

Whatever your knowledge of art and art history, I'll bet that after you play Master Pieces a few times, you'll have learned more about painting than you ever expected.

Now sharpen your eye and start looking—fiercely.

Tom Hoving

1

OPPOSITE

Luminous eyes, high cheekbones, flowing tresses, graceful limbs—this artist set a standard for beauty in the fifteenth century that we're still chasing today.

There are about five hundred botanically accurate varieties of flora (someone actually counted) in this painting, many of which bloom every spring in the hills of Florence, the artist's hometown.

Think Vivaldi. And pasta.

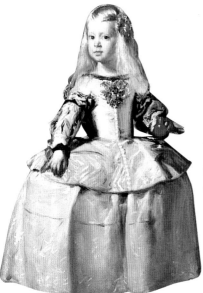

2

This Spanish princess's portrait was painted three times by the court painter who helped her father assemble an incredible art collection.

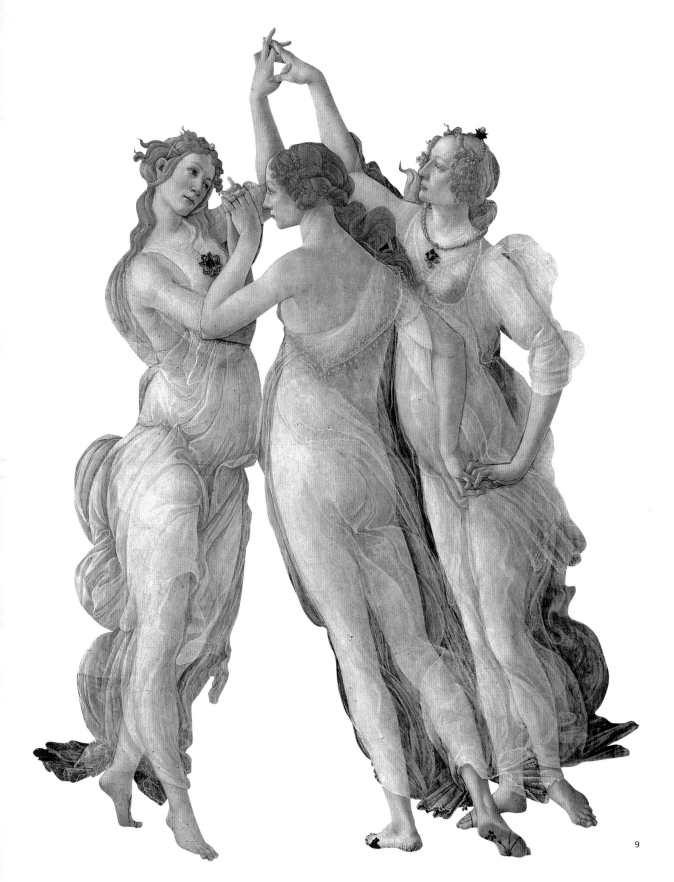

3

This solitary pole is the most human form in a painting that seems to be about loneliness and solitude—a statement that the artist would adamantly deny.

A leading proponent of Realism, this artist never understood why his fellow artists were obsessed with Abstract Expressionism.

This polelike woman is one of many obsessively arranged, solid lathe-turned figures enjoying themselves on a Sunday afternoon. Point after point, the artist's message becomes clear.

The artist was a loner, shutting himself off from the world for long periods of time to work incessantly. He was also very secretive—no one knew he had a mistress and child until two days before he died.

◆ **5** ◆

———

LEFT

This thin man marches in a bizarre parade created by a Belgian artist who wanted to challenge society's notion of beauty.

6 This young man is reaching for the "fruit of life" in a painting that was essentially a suicide note.

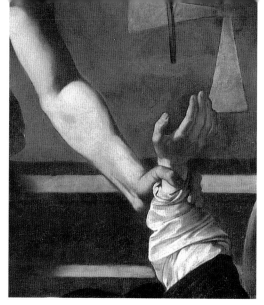

7 Murder in the cathedral, in chiaroscuro.

8 If you need a clue, one word is all you'll get: "Genesis."

BELOW

9 The fourth of May will never dawn for this Christ-like rebel.

10 An elegant youth in an elaborate allegory clears clouds away and heralds a warmer season.

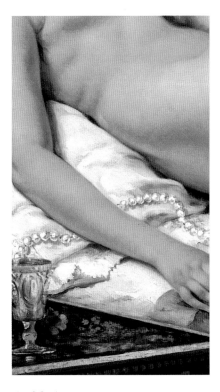

12 Liberté! Egalité! Fraternité! Decolleté!

◆ **11** ◆ This revolutionary French realist proclaimed, "I cannot paint an angel because I have not seen one." When he took up his brush to paint this luscious lady, the angels were with him.

ABOVE

13 Is this man making a political point, a poetic gesture, or a proposition? His companion seems ready for anything.

LEFT

14 In this rendition of the Greek myth, this beautiful woman is swept away by Zeus, who fell in love with her at first sight.

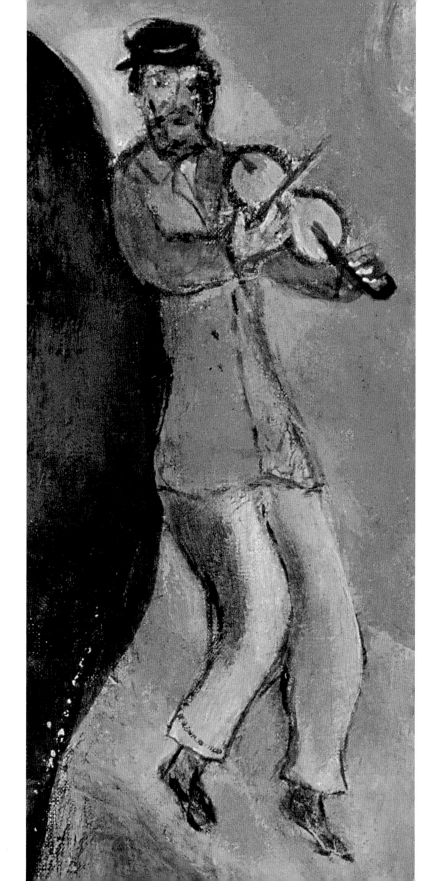

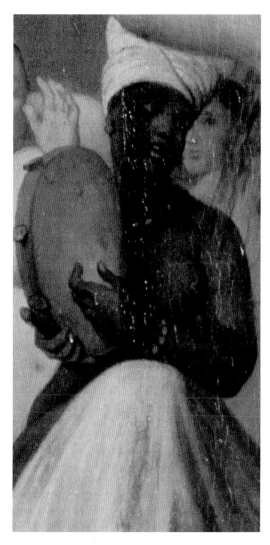

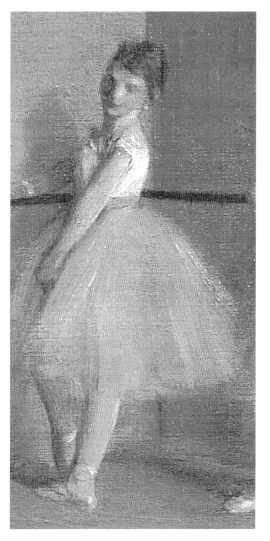

◆ **15** ◆ This French artist, a champion of traditional values and classical style, was fascinated with the exotic and the erotic.

OPPOSITE

16 This fiddler came decades before the Broadway hit that made him famous. The artist first painted a fiddler in 1920; it became his signature image. When the producers of a musical about the precariousness of Jewish life were looking for a catchy title, they saw the original image and were inspired.

17 Fiercely independent, this artist was wary of the Impressionists. He painted dancers, women bathing, racetracks, and bars and said that his works were meant to be viewed "as if through a keyhole."

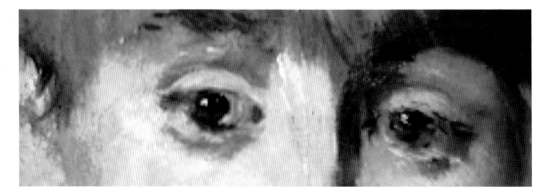

18 Tender eyes: This famous bartender seems more bored and tired than accommodating. She's a commanding presence in a circuslike society.

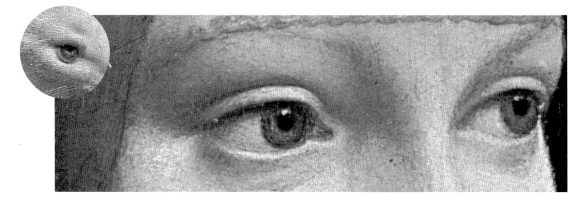

19 Penetrating eyes: This portrait is by an artist known for his mysterious women.

◆ **20** ◆ INSERT: Sinister eyes: But who is more evil, the beast or the beauty who has him in her clutches?

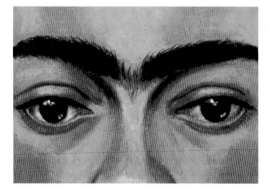

21 Dark eyes: She left her eyebrows ungroomed as a feminist statement.

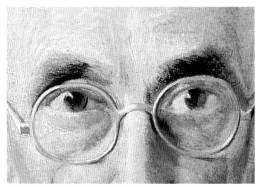

22 Heartland eyes: They are filled with solid Midwestern values—and perhaps worry, weariness, and wariness.

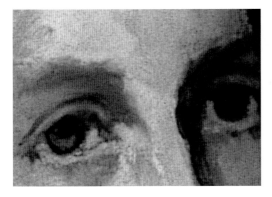

23 Feasting eyes: Painted by an artist known as the godfather of Impressionism.

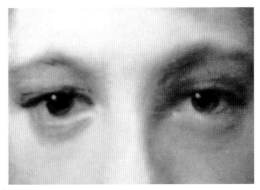

24 Brown eyes: This boy is famous for a suit of a different color.

25 Agonized eyes: Luckily this artist left his eyes unscathed when he went on a self-destructive rampage.

26 Bedroom eyes: These eyes belong to a merchant who posed with his bride in their bedchamber.

27 "Drink to me only with thine eyes": The god of wine, painted by the artist known as "the first Bohemian."

28

Viewers of this painting often have a strange feeling that someone is approaching from behind. And that is exactly what the artist intended.

Is she or isn't she? A few years ago, students at a British college tried to answer the question by reconstructing the dress and posing in it just like the woman in the picture. Everyone who tried it looked pregnant.

It was not customary for artists to sign their works during his lifetime, but this genius not only signed some of his masterpieces, he also added *Als ich kan* (as I can) occasionally. The humility of the phrase is amusing, since he is among the greatest artists in Western civilization.

◆ 29 ◆

Though he skewered British society and seemed like a muckraker, the artist who created this chandelier was a founder of one of England's most influential and conservative art institutions, the Royal Academy.

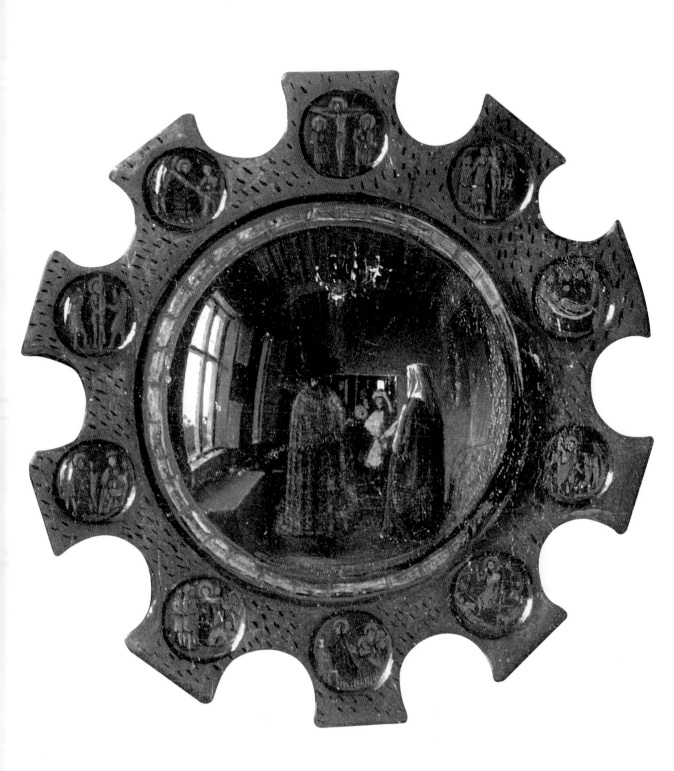

30

Thought to be the ultimate surrealist, he was
rejected by the surrealistic establishment because
he was also a publicity hound and an egomaniac.

Time doesn't fly, it oozes.

32

◆ 31 ◆

This clock has passed noon—another satirical statement about the decadence of the young lord who has just come home and the lady who has just finished an all-night card game.

The clock was painted by an English painter who created series of prints full of memorable characters, shrewd observations and amusing vignettes. All of society loved them and he profited handsomely. During World War I the copper plates he engraved for these popular prints were melted down for armaments.

This Russian émigré artist explained his work as follows: "I am against the terms 'fantasy' and 'symbolism' in themselves. All our interior world is reality—and that perhaps more so than our apparent world. To call everything that appears illogical fantasy, fairy tale, or chimera would be practically to admit not understanding nature."

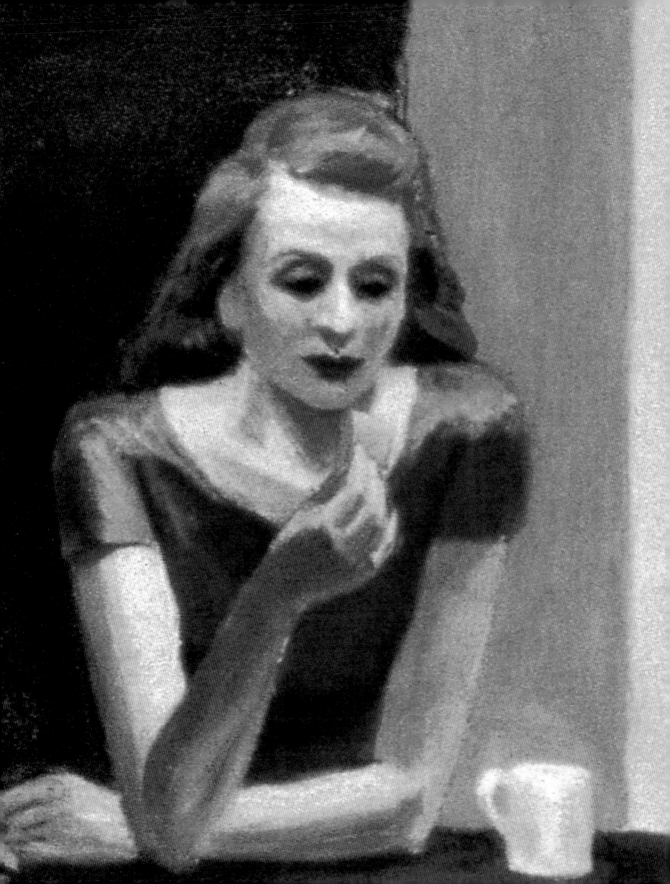

33

OPPOSITE

In the preliminary drawing for this painting, this American realist showed the woman engaged in conversation with the man next to her, highly unusual for this painter who was known for solitary figures. In the final work, she stares into space, alone with her thoughts.

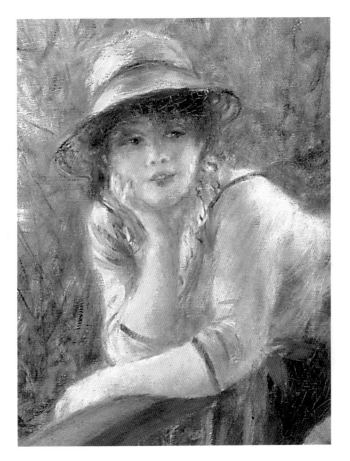

34

This French painter of insouciant but sometimes saccharine women said, "I do not know if I would have become a painter if God had not created the female bosom."

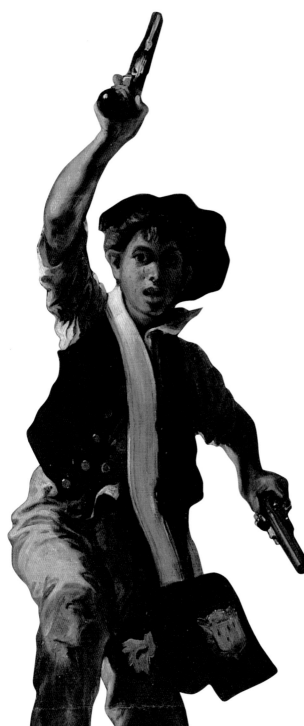

35

OPPOSITE

This soldier is part of a faceless machine that contrasts starkly with suffering human targets. The artist was memorializing a heartless massacre of three thousand peasants who tried to defend the old royal family when Napoleon installed his brother Joseph as king of Spain. But it also captures the essence of all tyranny and cruelty.

Following years of royal portraits and after a life-threatening illness that left him deaf, he created a series of fourteen "black paintings," about evil and despair, to decorate his villa. The villa was called the Quinta del Sordo (Deaf Man's Country House).

36

LEFT

This boy was Victor Hugo's inspiration for the young folk hero, Gavroche, in *Les Misérables,* described by Hugo as: "a whirlwind. . . . He vexed the loungers, he excited the idle, he reanimated the weary, provoked the thoughtful, kept some in cheerfulness, others in breath, others in anger, all in motion!"

This painting was a manifesto for a new political order. Its creator, who painted himself into the background, said, "Since I have not fought and conquered for the fatherland, I can at least paint on its behalf."

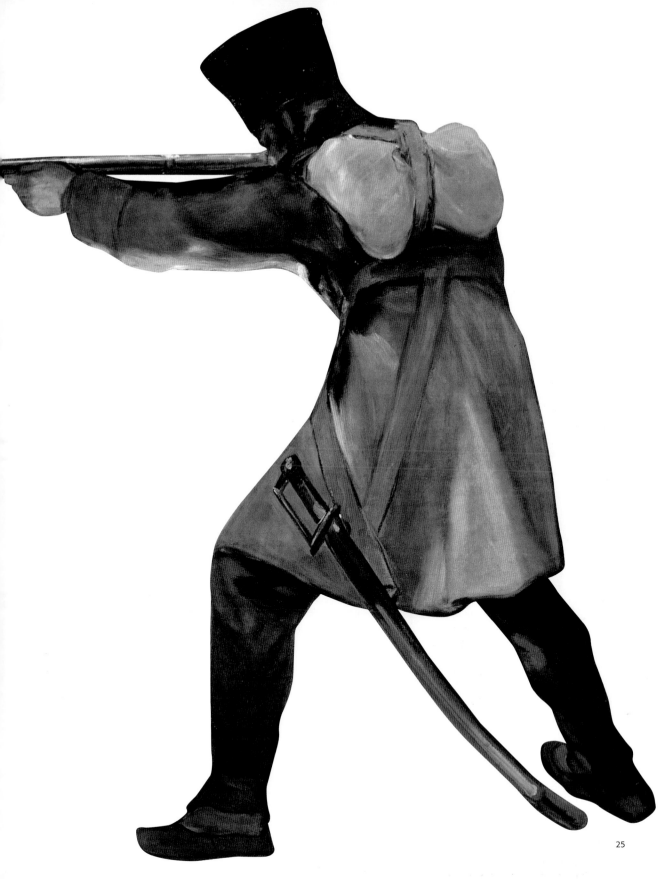

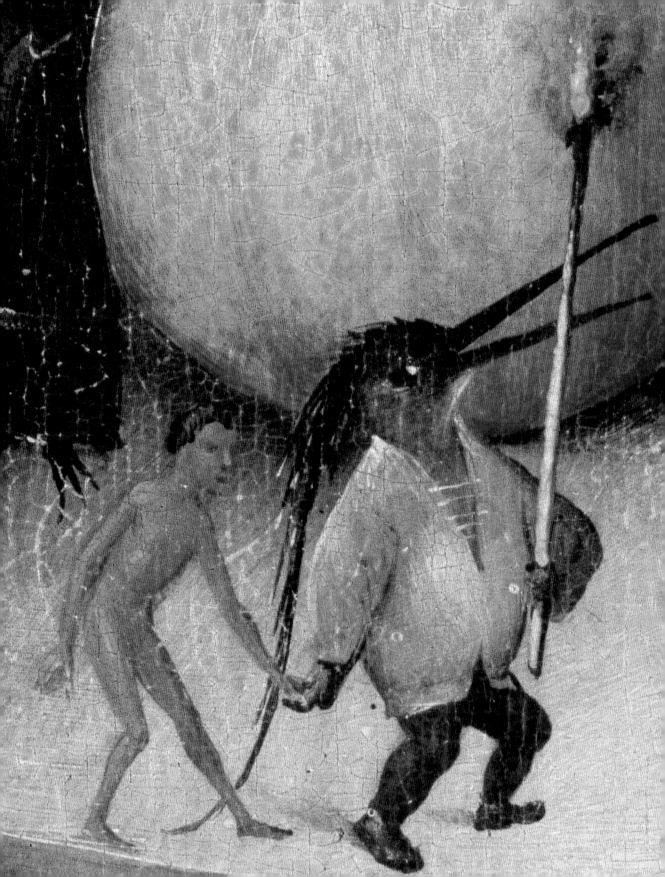

37

OPPOSITE

This detail is one of hundreds in a triptych that was commissioned as an altarpiece. At first glance the painting seems secular, illustrating lust and perversion rather than spirituality. But the images were fairly standard Christian symbols of sin and punishment in the artist's time.

The painter has been called "the first Freudian" because the creatures he painted could exist only in the subconscious.

Note the birdman's outfit. Did this artist invent blue jeans in the early sixteenth century? Or is there a Gap in Hell?

◆ 38 ◆

BELOW

This mother and child are fleeing a fire painted by the Master of Urbino, a Renaissance prodigy who amassed wealth and admiration by the time he died at age thirty-seven.

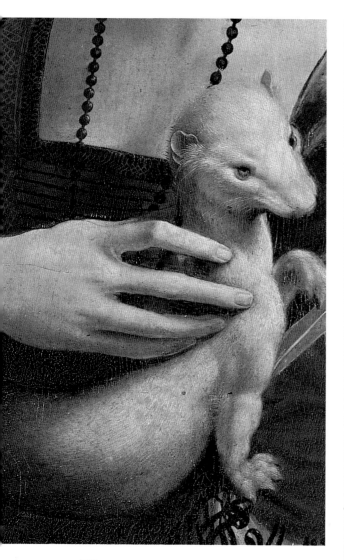

39 Ambiguous sweetness—or is it pure evil?—by the artist who was the original Renaissance man. His women had a softness that his rival Michelangelo never achieved.

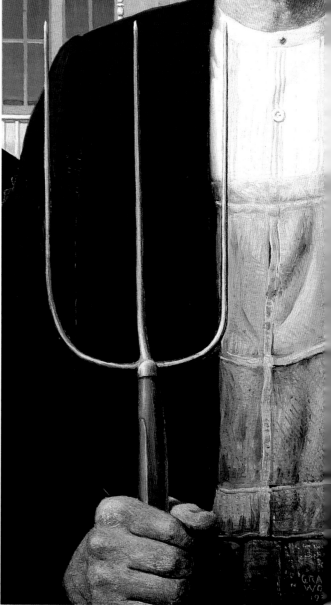

40 This painter stated, "All the really good ideas I'd ever had came to me while I was milking a cow."

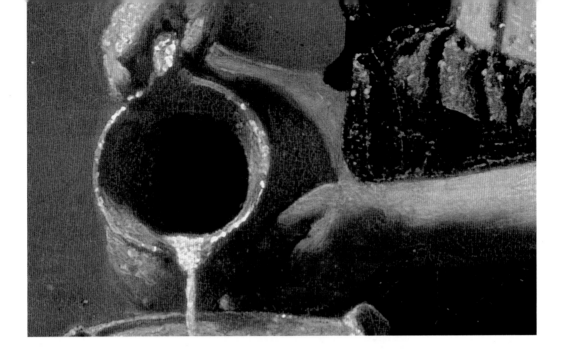

41 This Dutch artist lived in a small city known for blue-patterned dinnerware. His paintings, including this one, often showed women involved in domestic tasks.

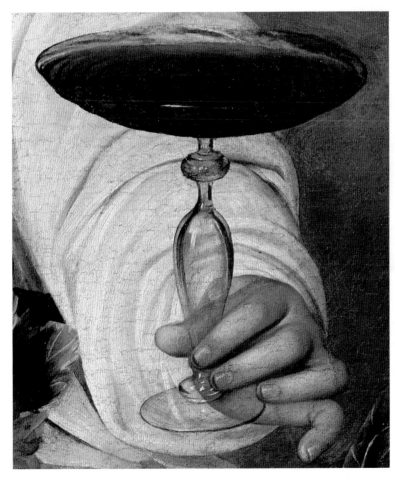

LEFT

42 This artist, like the subject of this painting, is known for drunkenness and debauchery. But his work shows discipline and great attention to detail—such as the beautifully drawn drapery visible through the stem of this glass.

43 & 44 These two beautiful bottoms were owned by a Turkish ambassador who liked soft-core pornography from world-class artists. The artists themselves could not have been more different—one was a groundbreaking French realist whose work inspired the Impressionists, the other a pioneering Neoclassicist with Romantic tendencies.

45 This detail was chosen because it shows the painter's mastery of soft, almost impressionistic glazes—but mostly because the artist's name alliterates so nicely with the word "tushie."

46 He impressed a new generation of artists, but all this artist really wanted was for his works to hang in the Louvre. It didn't happen during his lifetime.

47 This artist adored flesh and promised his many clients that their paintings would include "many beautiful nudes." Today his name is used as the root of a euphemism for plumpness and is a homophone for the name of a sandwich made with sauerkraut.

48 This British artist visited California and fell in love with the relaxed culture and athletic young bodies he found there.

◆ **49** ◆ This muscular backside represents a classical ideal of masculinity. Its creator painted and sculpted figures that were full of a special strength.

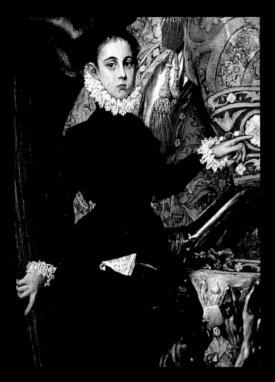

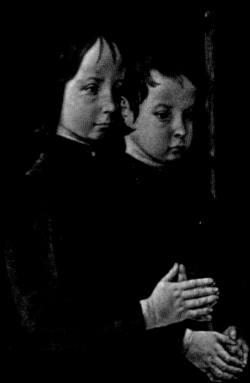

50 The artist himself and his son are the only people looking straight out at the audience in a painting filled with long-dead saints honoring a newly departed nobleman. He signed his work on the handkerchief in his son's pocket.

51 Who says you can't buy immortality? The father of these boys had his children, his wife, and himself painted into a magnificent triptych that celebrates the birth of Christ. The family was Italian, but the painter was Flemish, and this is the only work that is securely attributed to him.

52 A tad obsessive, this artist painted about sixty studies for this work. This little girl was originally painted as a lone woman in white. After many reworkings, the artist shrank her down in size and added her mother.

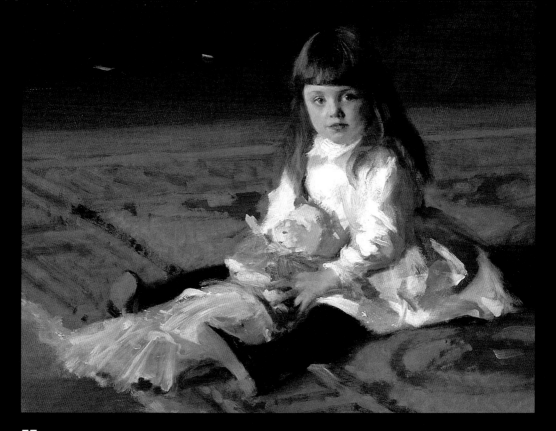

53 She's got all her sisters with her, but they don't seem to be one big happy family. Perhaps they were intimidated by the artist, a society painter who was both formal (he always wore a tie while working) and energetic. He would intently study his subjects, then suddenly leap at the canvas and confidently paint a perfect stroke.

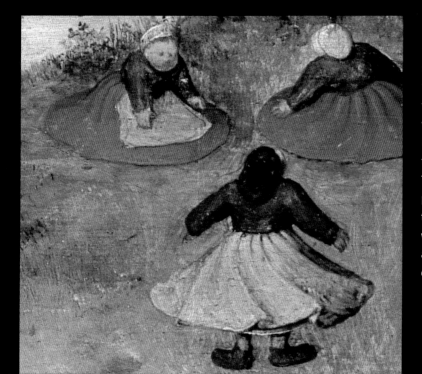

❖ **54** ❖ These medieval moppets seem to be singing, "Turn to the East; turn to the West. Turn to the very one that you like best"—or however that translates into Dutch. This circle game was painted by a well-travelled humanist who was one of the first artists to concentrate on common people.

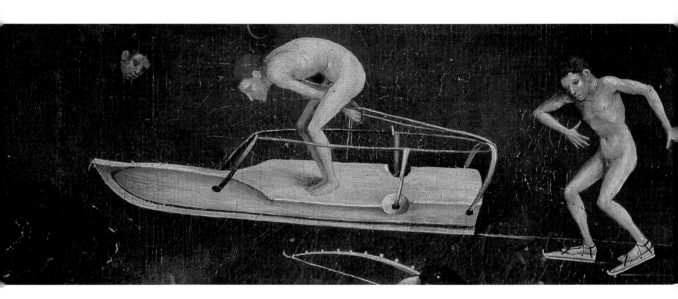

55

These skaters are on very thin ice and heading straight for a big black hole—but it can't be worse than the hell they're already in.

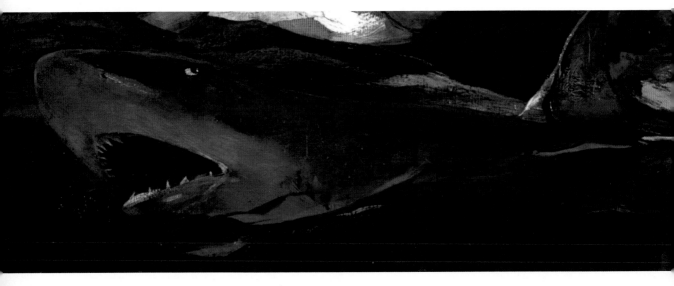

56

Will this shark devour its manly meal or will a
passing vessel rescue its prey?

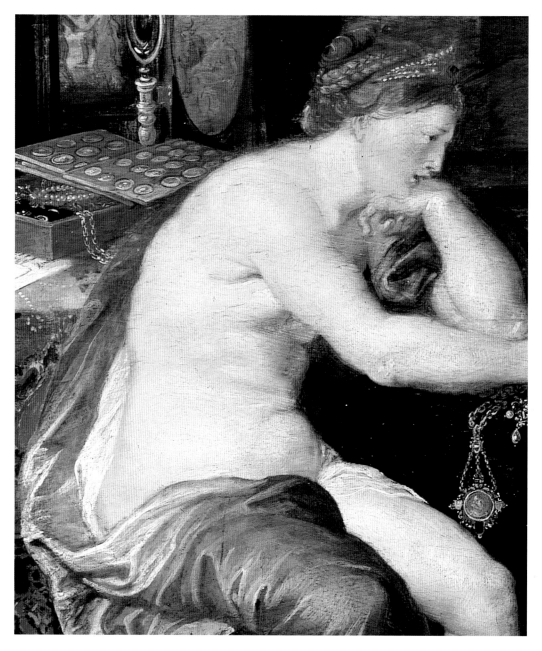

57

In a painting that's all about sight, this figure sits amid optical equipment. The painting is one of a series of works that depicted the five senses, from an artist who liked to paint in sequence.

58

This young woman is taking a break from a rather unconventional picnic. She and an even less modest friend give new meaning to the phrase "ladies who lunch."

This painting was rejected by the official Salon and instead exhibited by the Salon des Refusés, where it caused a scandal and drew harsh criticism from the art establishment. The artist was an iconoclastic pioneer who revolutionized the art world with his flat blocks of color and strong primary hues.

◆ **59** ◆ In 1508 the pope invited this artist to decorate some chambers in the Vatican on which work by other artists had already begun. After seeing this artist's first attempts, the pope ordered that the other paintings be destroyed and this artist was given sole control.

60 When this painting was first shown, it was titled *El Cuadro de Familia* (Family Painting). More than a century later, when public sentiment favored commoners, it was renamed to honor the entourage that served the royal family.

62 This sister hides in the shadows, distant from her three siblings. But forty years later, all four of them jointly donated this painting to the Museum of Fine Arts, Boston, as a memorial to their father. The vase, one of a pair, was also donated.

61 She may be fleeing criticism from an instructor or an unwanted advance from a wealthy patron. Or, she may be a set of curves and lines created simply to improve a composition by an artist who was praised for composition and chastised for misogyny.

63 In Mexico, monkeys represent death as well as vitality. No wonder they often appeared in the work of this artist, who carried the scars of a near-fatal accident and an overwhelming passion for life.

There was only one show of her work in her native land in her lifetime, but today she is officially recognized as a "national treasure."

64 Monkey see, monkey do—which makes his inclusion in this crowded painting appropriate.

65 He was a Quaker preacher who moonlighted as an artist to support his family. His congregation disapproved of his second job, so he tried farming instead. But he was not a very good farmer, and as Quaker preachers don't receive salaries, his art was accepted as a necessary evil.

66 This artist claimed his jungle scenes were inspired by his travels with the French Army in Mexico. Nice story, but not true; though he did serve in the French army, he never left France. He found the images in nature books and in an exotic plant nursery in Paris.

67 This Renaissance artist was known for paintings that were populated by strange, mythological creatures—including this tall, thin, idiosyncratic figure.

68 This painting was reworked and "improved" by this popular American artist after it was first exhibited. The subject matter was too threatening and disturbing for collectors, so he painted a boat in the distance, a suggestion of a possible rescue.

◆ **69** ◆ His work was loose, brushy, and bright. He recognized that shadows, traditionally painted in brown and blackish hues, were actually more purple and blue to the eye.

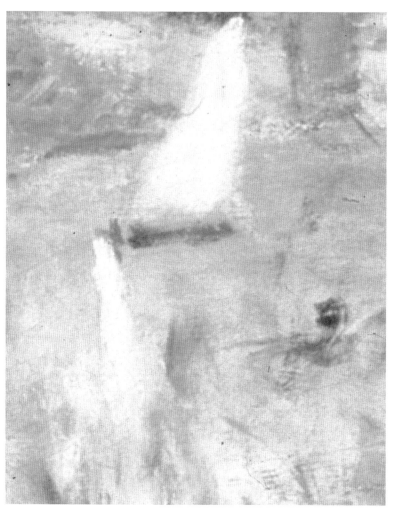

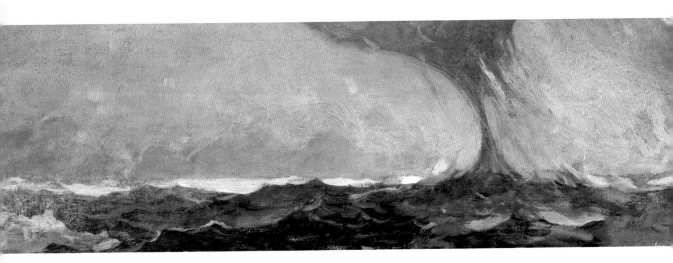

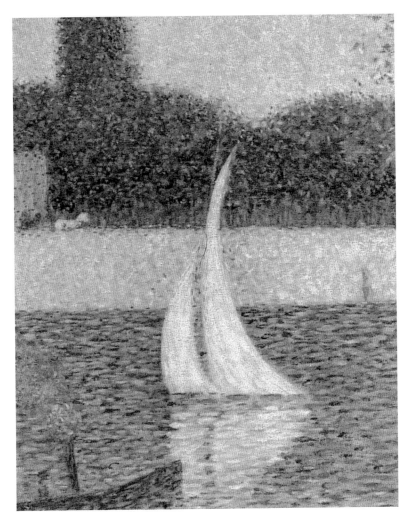

70 Art was no day in
the park for this artist;
he meticulously
followed exacting
optical theories. His
point: that dots of
color, placed separately
on the canvas, can be
blended by viewers'
eyes more accurately
than by the painter's
brush.

71

This artist's life was full of screaming kids—he had eleven of them—yet he painted scenes of utter tranquility and peace.

Follow the light. His paintings are famous for it. You can actually see the dust particles in the air.

He died penniless—his wife settled the baker's bill with two paintings—and dropped into obscurity until the nineteenth century when his works were rediscovered by a French art critic.

72

"Dear Lord, thank you for our ketchup."

Though wildly popular for his magazine covers, this artist was self-critical and negative. When he first painted this piece, he hated it and threw it out his studio window into the snow. He mentioned it to another artist that night at the local tavern; the second artist, knowing his friend's contrary nature, agreed that he had done the right thing—whereupon this artist changed his mind and retrieved the painting. It's one of the best-known of his many familiar pieces.

73

His paintings have become icons of the alienation and the emptiness of modern life. This artist rarely acknowledged the psychological element of his work, though it is what impresses most viewers.

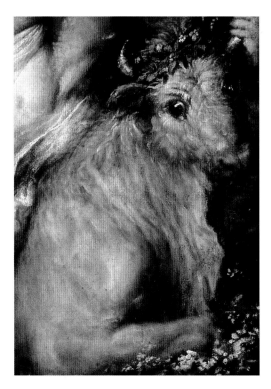

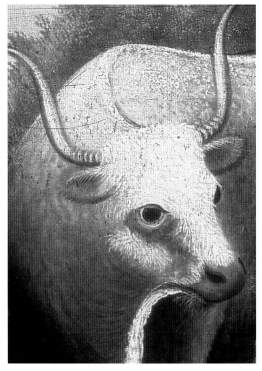

74 Here's the main character in a cock-and-bull story. The artist lived and worked for a long time, but no one knows quite how long. He inflated his age by about ten years, and then demanded higher prices because he was a senior citizen.

75 This artist's Quaker upbringing and a passage from Isaiah inspired his choice of subject, which he repeated, with slight variations, more than one hundred times.

◆ **76** ◆ He was a master at organizing space. In this extraordinarily complicated triptych, he presents several fully realized vignettes. Unfortunately he was never able to keep order in his own mind.

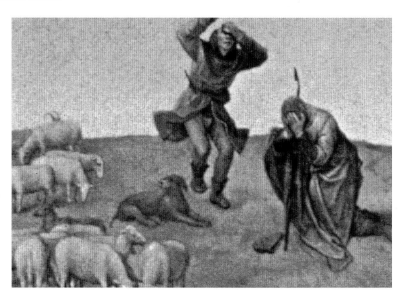

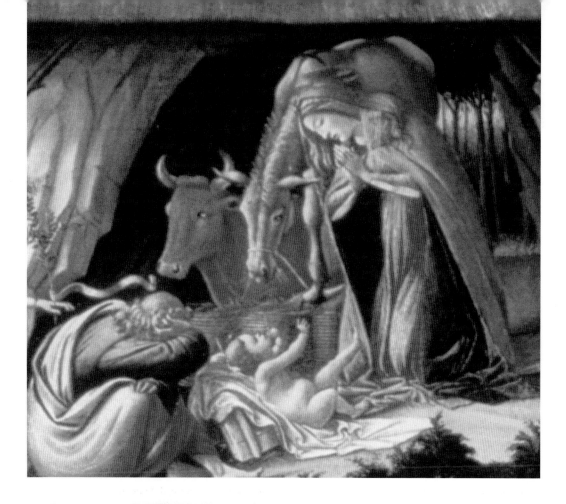

77 This painting was done after the artist converted from secular humanism to become a follower of a fire-and-brimstone anti-Medici preacher. Note how he's focused on the Madonna—she's so disproportionately tall that she'd hit her head on the roof of the manger if she stood up.

78 Most of us would consider this British painter's work conservative and conventional. In his personal life however, he was passionate and innovative. He fell deeply in love with a minister's granddaughter and married against her family's objections. And he developed his own style of painting, paying close attention to every detail of the natural world.

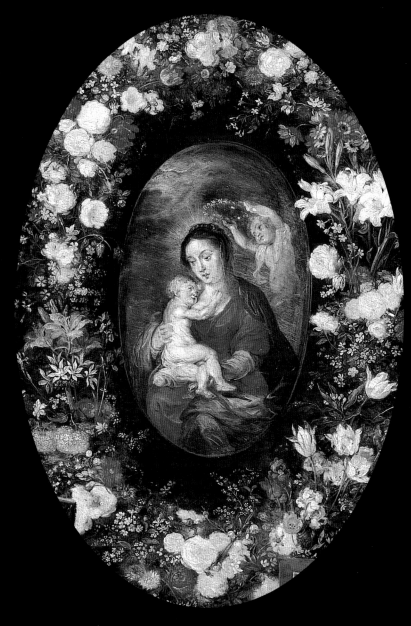

79

Tit for tat. This painting within a painting, a copy
of Rubens's *Madonna in the Flower Wreath*, was
probably added by Rubens himself; the rest of the
piece was created by the artist who did most of
the floral work in Rubens's masterpieces.

80 Vasari called him the prince of painters; this artist also served as architect of St. Peter's and joined in excavations and surveys of Roman ruins

81 There have been debates about what the images in this mirror are doing. Are the king and queen arriving to see how work on their daughter's portrait is going? Or, as some critics believe, are they posed so the artist (who is looking directly at them) can include them in the painting? It is a visual conundrum that has never been solved.

82 These ugly little sculptures are intentionally kitschy, just what a pretentious young lord and lady might collect.

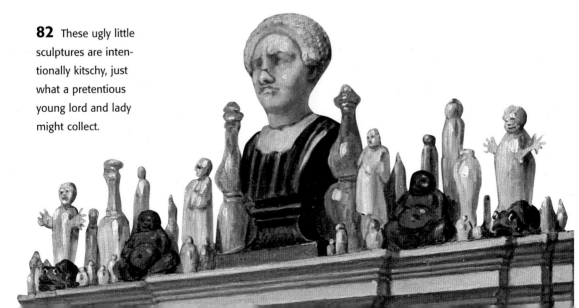

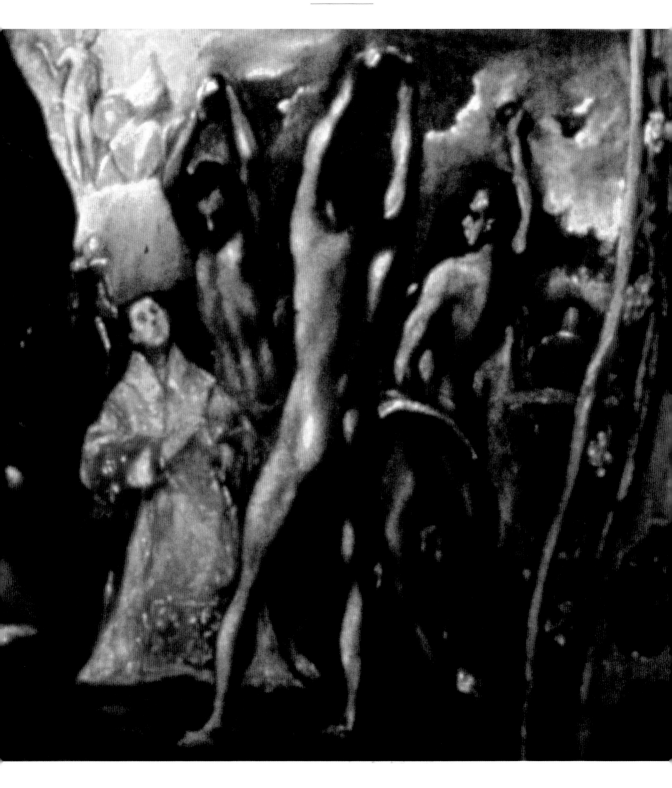

83

In a painting by an artist whose elongated figures evoke spirituality, even the costumes tell stories.

His paintings are full of yearning souls. His people sway in divine rapture.

He avoided daylight because, as he said, "It blinds the light within."

◆ 84 ◆

This Old Testament scene is a tiny part of a chapel filled with frescoes that illustrate the life and Passion of Christ.

85 Is this fluffy little dog his or hers, or just a symbol of their promise of fidelity?

◆ **87** ◆ Dogs are known for their keen vision, which is appropriate for the subject of this complicated painting.

88 A fixture in a cityscape of loneliness.

86 A faithful pet in a marriage doomed to infidelity and ruin, painted by a British master of social satire.

89 You won't get much more than a blurry impression of this dog unless you view it from ten feet back.

90 Which cat is coming, which is going—and where have they been?

91 Well-fed but still greedy, this pet has the same expression as some of the kings and queens whom this artist painted. His subjects never realized that they were being ridiculed.

93 The style is one of many points, and the artist is a pure theorist.

92 This sentry accompanies a future queen. The court painter painted three portraits of the little princess. These paintings were sent from the Spanish court to the Austro-Hungarian Empire because the child had been promised in marriage to the future emperor.

94 During her short lifetime the mistress of this sinister feline was the victim of a serious bus accident and intense emotional stress.

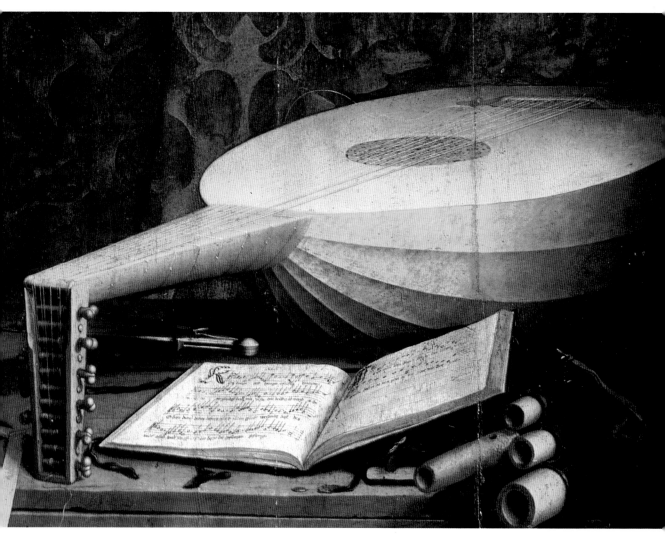

95

An artist whose client list consisted of such heavy
hitters as Erasmus, Martin Luther, and Henry VIII,
painted this musical instrument in a portrait of two
up-and-coming diplomats.

ABOVE

96 This Flemish artist was also an astute businessman, salesman, and politician. He maintained a busy workshop, where several assistants fulfilled many of his commissions.

LEFT

97 This dreamy musician lives in a dreamlike primitive world of an imaginary Africa, created by a French artist whom Picasso called a "new realist, the last and greatest of the ancient Egyptian painters."

98 A big vase of flowers, from the artist known as "Little Flower."

101 It is easy to miss this lovely vase in this highly erotic painting, done by a revolutionary realist. The scene in the foreground is, shall we say, distracting.

100 These flowers are symbols of the suffering and Passion of Christ. They stand in an apothecary jar that was usually used to carry herbs and medicines. The Flemish painter ingeniously hinted at the location where the painting would hang: a hospital chapel in Florence.

◆ **102** ◆ Animals were not this Flemish artist's forte; he was more interested in landscapes and flowers.

BELOW

103 Horseplay, from a Dutch master who painted a scene of unexplained fun and games.

The battle depicted in this scene was a real one; it took place on June 1, 1432. The painting was commissioned by the victorious Florentines.

The artist's wife complained that he often stayed up all night working; when she asked him to come to bed, he'd say, "What a sweet mistress is this perspective!" Some critics say that his art is too involved with technical problems to achieve true greatness.

105 There's nothing serious or weighty about this horse; it seems to be stuffed with cotton. The horse's flat, unarticulated face indicates that this painting was done before the end of the fifteenth century.

RIGHT

◆ **106** ◆ This scary monster, an easily missed detail in an altarpiece by a Northern Renaissance genius, lies under the feet of Saint Margaret, the patron saint of childbirth. Legend has it that Saint Margaret was swallowed by a dragon but found her way out (we leave the connection of this legend with the miracle of childbirth to our readers). The artist, plagued by monsters of his own creation, went mad.

RIGHT

◆ **107** ◆ His real name was Felipeppi, and he was a pupil of Filippo Lippi. For many years he enjoyed the patronage of the Medicis, but he later fell under the spell of a preacher who called the Medicis devils.

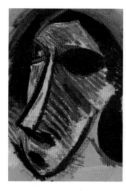

108 Is this a face, a mask—or a whole new way of seeing?

BELOW

109 From a Swiss painter who moved to England: a *memento mori* for two young masters of the universe.

LEFT

110 Many of us see only the phantasmagorical monsters in this painting, and we miss the artist's underlying musical theme. Musical instruments appear throughout the painting, though it's unclear why the artist thought that hell was musical.

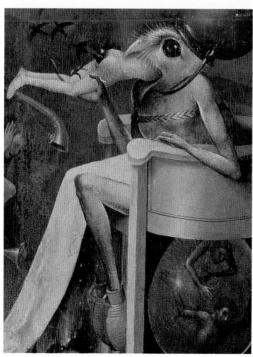

◆ **111** ◆ He's not a monster, but he painted a lot of them. Here, he hides himself in hell.

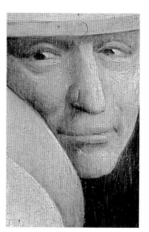

112

This woman is often mistaken for a beautiful young girl, but in truth she was middle-aged and crippled. The artist painted her several times, and in other portraits she is much less lovely.

◆ 113 ◆

This head is part of one of the largest paintings in the world, which includes over six hundred twisting and turning bodies. The artist was originally commissioned to paint just one segment, but instead he did it all. He was seventy-five-years old when it was completed.

114

Franklin Delano Roosevelt commissioned this artist to paint the "portrait of America." Millions of copies of the resulting patriotic image were distributed to help rally the country and sell war bonds.

115

The hat makes her seem even more naked. Noted for his exotic, elongated nudes, the artist also had a passion for painting fashion, showing every button and swath of lace in minute detail.

116

117

After the Revolution of 1830 radicalized him, he started painting realistic scenes instead of copying moments from antiquity. He said, "No age can be depicted except by its own artists."

This carafe of wine is just the right prop for a painting in which the artist dressed up one of his favorite models—a boy he met on the streets of Rome—as a god.

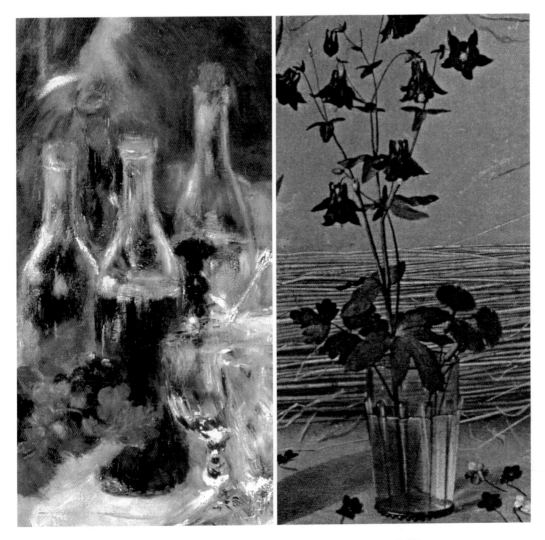

118

119

All we see is charm and fun, but the painting has a strictly formal design, with a symmetrical structure. This still life is highly detailed—even the bottles have reflected images. And the people all seem individual, full of personality—even when we see only the backs of their heads.

These humble columbines in an ordinary household glass are front and center in a spectacular altarpiece. The artist, who found life full of anxiety and fear, retired from the world and joined a monastery when the painting was finished. He's an early example of the fine line between creativity and insanity.

120 Saint Anthony was included in this altarpiece because he is the patron saint of little Antonio, the son of rich Tommaso—the Medici's agent in Bruges, near the home of the Flemish artist—who commissioned it for the chapel of a Florence hospital.

121 This accountant is the only one who is concerned about the profligate lifestyle of a newly married couple in one of a series of paintings by a British artist whose acid wit exposed both the rich and the poor.

122 A rival of Michelangelo and Leonardo, this artist is renowned for tender and serene women, especially Madonnas. He died young, and some say it was because of "an excess of lovemaking."

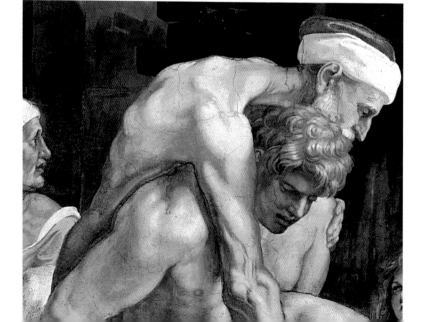

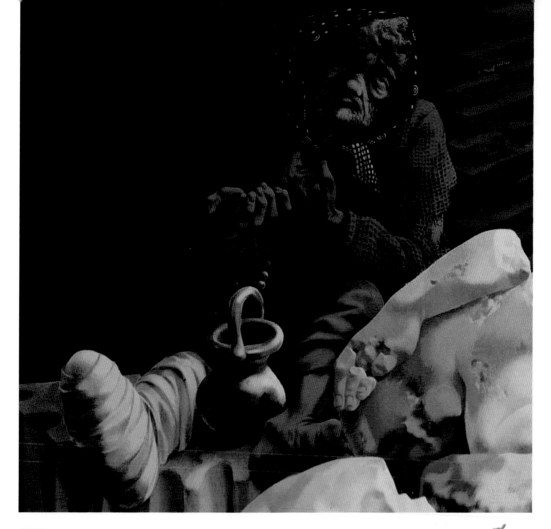

123 Many of this Russian immigrant's paintings commented on politics and society. He said, "We, as artists, must take our place . . . on the side of growth and civilization against barbarism and reaction, and help to create a better social order." Some of his work was done under Roosevelt's WPA program.

124 He was long disparaged as a sentimentalist by the art community, but this artist understood American people—and American people love his work because they understand it.

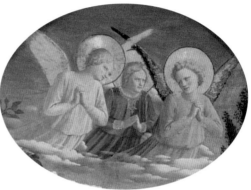

125 Here comes the queen! This is one of twenty-four paintings she commissioned to show that she was beautiful and beloved. In reality she was neither.

127 With a name like that, of course he painted angels!

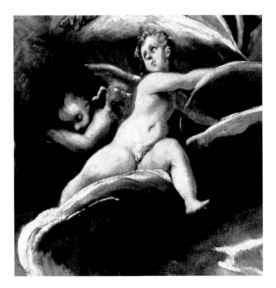

126 This artist was the first to enter the third dimension and paint people who seemed round and solid. This detail is one of a flock of angels in the background of a mournful scene. It seemed like a miracle to his contemporaries, who were not used to seeing real people in art.

128 He was trained as a painter of religious icons, and retained an ability to paint deeply spiritual faces.

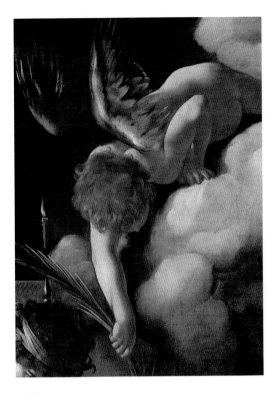

129 Even the angels that this "bad boy" painted were dramatic studies of holy light and darkness.

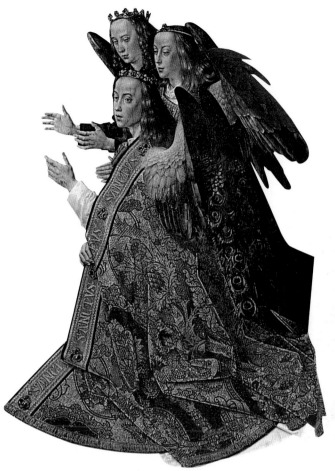

131 Savonarola's fanaticism is sweetened by the hand of this Renaissance painter whose trademark is beautiful women, whether human or celestial.

130 Commissioned by an Italian banker who worked in northern Europe, this altarpiece includes fifteen angels, each one dressed as if for a celestial fashion show.

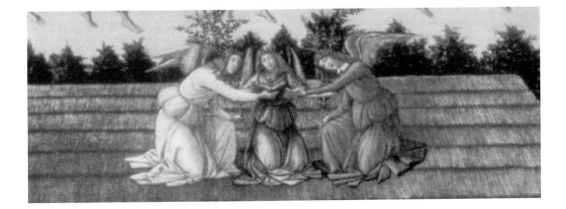

132 This English artist thought it was important to transcribe nature as accurately as possible; he studied meteorological charts to get the clouds and shadows exactly right.

◆ **133** ◆ Tree climbing fits nicely in a painting where leapfrog, knucklebones, ninepins, and a couple of dozen other games are featured.

134 Critics complained that the artist forgot to paint the shadows in this outdoor picnic scene.

◆ **135** ◆ The beasts of the jungle and a bevy of farm animals mingle in peace as onetime enemies lay down their arms beneath this tree.

136 His mother named him Guido, but he was called *Beato* in reference to both his works and his character. He never picked up a paintbrush without saying a prayer.

137 There's no question about the focus of attention in this painting: All eyes are on Christ. Even the tree seems to be leaning toward him.

138 TOP MARGIN An odd bird from an odd painter, who ate only hard-boiled eggs.

◆ 139 ◆

OPPOSITE

This artistic monk was known for his piety as well as for his understanding of advanced artistic techniques. But his art was all for the glory of God.

He was beatified as a patron of artists in 1983, more than five hundred years after he died.

This depiction of Jerusalem is not quite accurate—hardly surprising considering that the artist never saw it. His work—like that of other artists of his time—was based on a set of measurements that were considered sacred.

140

These builders appear in one of five paintings based on Ovid's *Metamorphoses* and the history of primitive man—all created by an eccentric Renaissance painter.

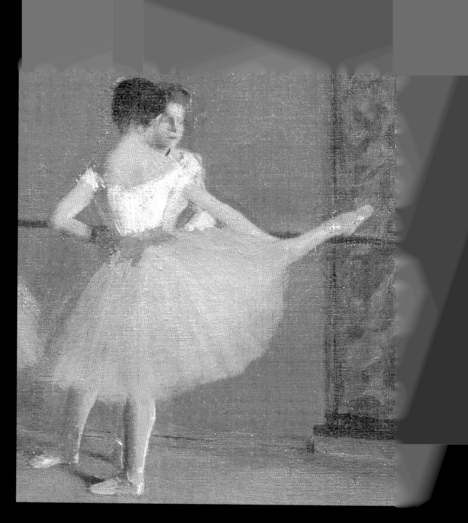

RIGHT

141 This Parisian artist had relatives in the United States. He visited New Orleans and painted its Cotton Exchange.

BELOW

142 This humanist artist abandoned a tradition in Renaissance painting—in both Italy and the northern lowlands where he was born—of focusing on religion. The ordinary and familiar were his hallmarks.

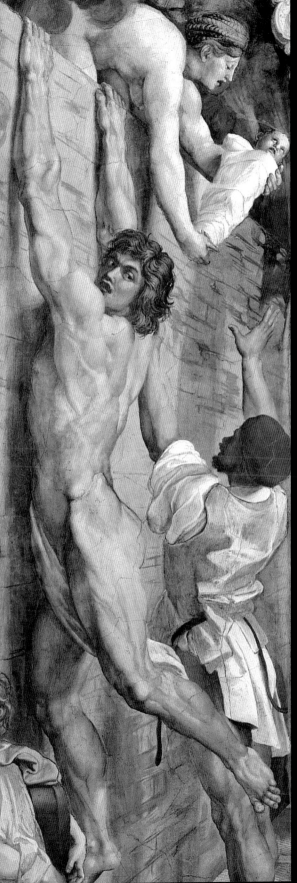

143

LEFT

This naturally talented artist learned to paint from his father and studied the works of his contemporaries. His reputation was made early in his life when Pope Julius II, the "Warrior Pope," summoned him to Rome.

144 This artist specialized in meticulous paintings of one of the world's most beautiful cities and the water that surrounds it.

145 Address: 1 Hell Street, between Sin and Punishment.

◆ **146** ◆ This stately home is the work of a landscape artist who moved his easel outdoors before the Impressionists were born—but he finished his paintings indoors.

◆ **147** ◆ This artist's work—he specialized in lush landscapes and floral still lifes—is very different from that of his father, who preferred painting common folks.

148 The whole town is frolicking in front of the city hall of a northern European city, painted by an artist who was first in a line of elders and youngers.

◆ **149** ◆ Hundreds of peasants gathered to defend their monarchs from Napoleon's soldiers in front of this building, with tragic results.

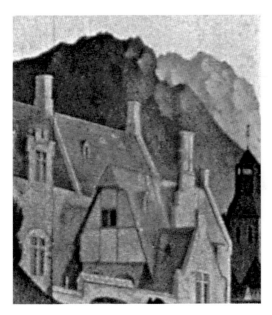

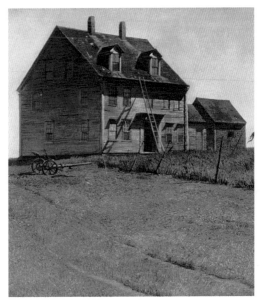

◆ **150** ◆ This image appears in the background of a Renaissance masterpiece's center panel, one of several intricate scenes that complement the main event, the Nativity.

151 If you don't immediately recognize this weatherbeaten Maine farmhouse, picture it at the top of a hill. Think of the farmhouse as a destination, a faraway goal to be reached.

152

This artist is known for his facility in altering the tone of his works to match their subjects. Some of his works are light and entertaining; others, including this one, brilliantly depict a dark reality.

153

This painting portrays Mussolini as a jackass out
of his box. The artist's hyperrealistic paintings often
had anti-fascist themes.

154
LEFT

The commonplace orange on this windowsill may represent fertility; it appears in a work that has been called the first domestic portrait.

155

One of the most famous American paintings was inspired by this Gothic window and house; the artist immediately sketched it and had it photographed. But the people whom he posed in front of it are much more familiar.

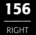

Though he was known for beautifully balanced compositions and pure, vivid colors, light was his true subject. In most of his works, light coming from a left-hand window illuminates an interior scene so realistically that the air seems to shimmer.

157

LEFT

The early-morning light highlights the plainness and solidity of this urban row house. It's a poetic backdrop for a deserted street scene.

◆ 158 ◆

◆ 159 ◆

Born in Crete, this artist moved to Italy but clashed with the Renaissance crowd—he boasted that he could have done a better job than Michelangelo on the Sistine Chapel. He ended up in Spain, where he prospered.

His name has become an adjective, defined as a brownish orange color, which refers to the auburn hair on many of his voluptuous women.

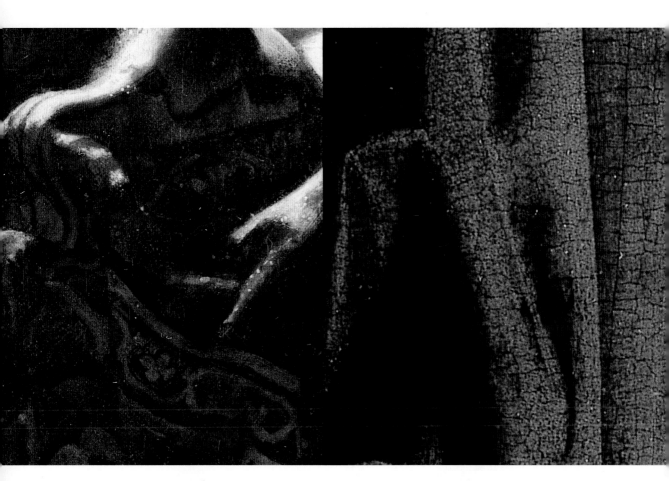

160

Richly colored and beautifully draped rugs often appear in the foreground of paintings by this Dutch master, who was also an art dealer.

161

This artist has been called the inventor of oil painting. He wasn't, but he did refine the medium by mixing pigments with oils to create brilliant, transparent glazes. Nor did he invent realistic painting. But his work is so detailed and realistic that a contemporary described one of his paintings as "lacking only a voice."

◆ **162** ◆ In a fantasy jungle, leaves of dreams.

◆ **165** ◆ Petitions are circulating in Padua and throughout the world to save the fourteenth-century chapel in which this groundbreaking art appears; it's in danger of water damage.

◆ **163** ◆ This Renaissance great apprenticed in embroidery before he learned oil painting—maybe that's why these tiny flowers are so precise.

164 This psychedelic pattern looks almost cheerful, but the artist was obsessed with death, illness, and self-doubt.

◆ **166** ◆ A spot of color amid flesh tones, from a French Neoclassicist.

BELOW
◆ **167** ◆ A fleur-de-lys cape symbolizes all France welcoming a returning queen.

LEFT
◆ **170** ◆ These floor tiles under the feet of two young diplomats are not merely decorative; they're based on complicated math-ematical theorems.

ABOVE
168 The wild energy seen in this back-ground was a warning of the artist's anxiety and self-doubt; he later shot himself.

LEFT
169 This cloth of gold brightens the funeral of a Spanish nobleman.

ABOVE
171 A battle for Florence begins with swords drawn; the artist was more interested in their vanishing points than in the outcome of the combat.

172 Painted by an artist in the middle generation of a great American art dynasty.

◆ **173** ◆ His colorful and dramatic works are full of religious and mythological symbolism; here the hand of Neptune pulls a barge.

174 Some critics say that this artist's customary elongation was caused by eye trouble; it is actually a method of deepening emotional effect..

175 Blood and violence were often elements in this artist's work. His intense lighting heightened the already exaggerated emotion.

176 This High Renaissance artist is famous for his portraits of royalty, his glazes, and some pretty risqué nudes.

177 Lady Liberty marches barefoot to the barricades.

178 Just as spring arrives, this young woman enjoys a barefoot romp in the forest, strewing flowers as she goes.

179 Did she remove her shoes and socks at this lovely picnic so that she could feel the grass under her feet—and then get carried away?

TOP

◆ **180** ◆ Gothic tragedy.

TOP

◆ **181** ◆ Roccocco cielo.

ABOVE

◆ **182** ◆ Renaissance
creation.

ABOVE

◆ **183** ◆ Northern
Renaissance brimstone.

◆ **184** ◆ Baroque domesticity.

◆ **185** ◆ Romantic uprising.

◆ **186** ◆ Italian mystery.

◆ **187** ◆ Impressionist choreography.

188 Hat and head by Paolo di Dono. We know him by his nickname, which refers to his love of birds.

189 Robes by Henry VIII's court painter, who painted portraits of prospective wives for the much-married king. In one case, the monarch fell in love with the painting, but hated the actual woman when he finally met her.

190 Sash by a Spanish artist who sometimes injected a sardonic note into commissioned portraits. Here, he seems to imply that an angelic toddler is about to feed his bird to his cat.

191 Shoes by a British artist who painted a boy with buttons and bows and a winning smile.

192 Hat by a French Impressionist who later married the woman who wears it. She bore him two sons, one of them a legendary film director.

193 Face by the high Renaissance artist who painted quiet beauty (and was quite handsome himself).

194 Bodice by a seventeenth-century Dutch artist who fell into obscurity until he was rediscovered in the nineteenth. He is reputed to have used a *camera obscura* to trace some of his work.

195 Robe and hands by an artist whopainted as if he was using both a microscope and a telescope.

196 Skirt from a painting about hope for political change in the 1800s. The king bought it and hid it for years so that it would not incite further unrest..

197 Respectful

◆ **198** ◆ Doomed

199 Lonely

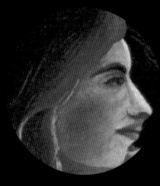

200 Dreamy

◆ **201** ◆ Bellicose

202 Diplomatic

203 Watery

◆ **204** ◆ Rebellious

205 Original

206 Mournful

207 Saintly

208 Domestic

209 Immodest

210 Maidenly

211 Almighty

212 Worldly

213 Fleshy

214 Mercurial

GALLERY

On the following pages, you'll find the 56 paintings from which all our details are taken. These paintings are arranged in approximate chronological order, from Giotto, our earliest artist, to Hockney and Wyeth, who are still working. The alphabetical list below will help you find the artist you're looking for.

The essays that accompany these paintings provide an overview of each artist's life and work. If some of our clues seem a bit cryptic, the essays will explain them.

We've used at least one detail from each masterpiece. In some cases, the detail is not positioned in the same way that it appears in the painting. But they're all here—just keep looking. If all else fails, there's an answer key on page 176.

◆◆◆

Giotto, 1267–1337, Italian
The Lamentation, ca.1305
Fresco, 78³/₄ × 72³/₄ in (197 × 182 cm)
Arena (Scrovegni) Chapel, Padua, Italy

How many times in the history of art can we say without the slightest doubt—without a single plausible counterargument—that one man truly changed its course? Giotto di Bondone—the genius who freed art from the harsh, repetitive conventions of the thousand-year-old Byzantine artistic style—was such an artist. Giotto singlehandedly brought life, substance, and three-dimensionality to painting. Without him the Renaissance would not have happened.

We know little of Giotto's life but surmise from his early style that he studied under the Florentine great Cimabue. Giotto's finest surviving work is the series of frescoes depicting the life of Christ in the Arena, or Scrovegni, Chapel. Giotto makes the story seem fresh, laden with tension and a profound sorrow.

The Lamentation, set against a stark rock on which a single, leafless tree grows, is perhaps the most moving of the cycle. As a crowd looks on, Mary cradles her dead son in her lap; her expression and her posture capture the essence of human grief. The figures have real bulk and are solidly grounded as opposed to representations from earlier periods in which characters seem to float. The two shrouded women who bracket the scene—as enduring as rocks—are like the mute, mourning peasant women who seem to be present at every sad event. The infinite sadness of *The Lamentation* is enhanced by the grief-stricken expressions of ten startling angels who wheel in the skies, almost audibly crying out and keening.

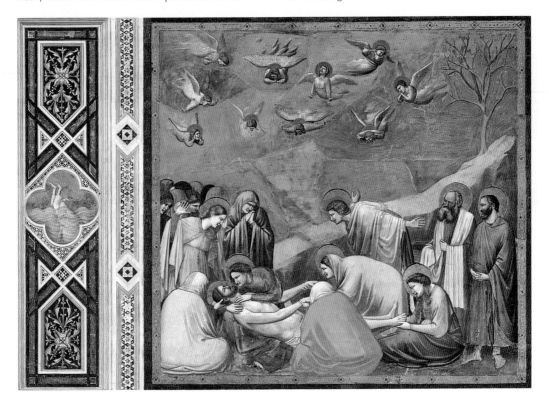

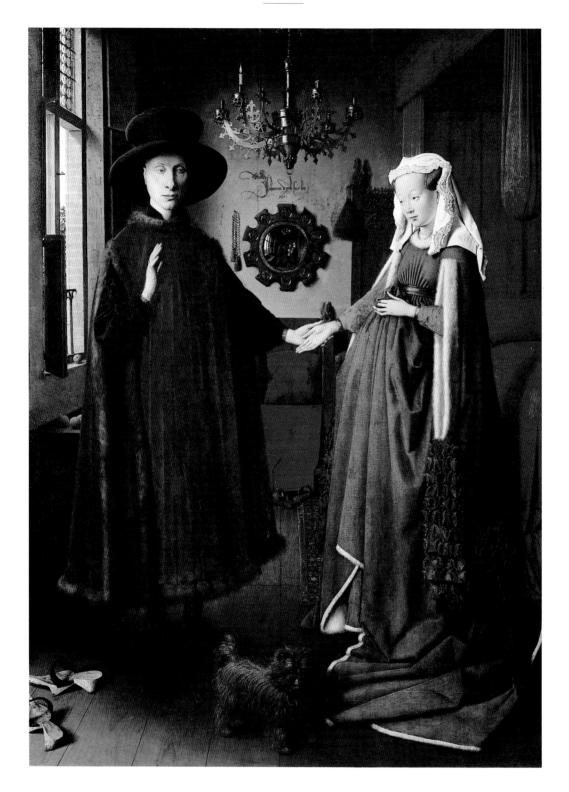

Jan van Eyck, 1390–1441, Flemish
The Wedding of Giovanni Arnolfini and His Wife, 1434
Oil on wood, 33 × 22 1/2 in (82 × 60 cm)
National Gallery, London, England

Until about 1400 the supremely elegant International Style (also known as the Beautiful Style) dominated European art. By 1425, this style was replaced in one of the most profound artistic revolutions in history, known as the Northern Renaissance. The artist responsible for this radical change was Jan van Eyck, who turned to oil painting after starting his career as an illuminator. Oil allowed a greater depth and subtlety than did the traditional medium of egg tempera: quick-drying layers could be loaded one on top of another. The pigments, suspended in multiple layers of oil, became intensely brilliant. Because of the stability of oil paint, the tiniest details and delicate nuances in shading became possible.

Jan van Eyck was not the first artist to use oil, but he took oil painting to new heights. Distances are accurately depicted, gold and brass glisten, candle flames flicker, and mirrors reflect actual images. For the first time in painting, incredibly complex shadows appear in subtle darker-to-lighter bands as they do in nature. Contemporaries marveled at their realism; one said his works "lack only a voice." A later critic noted that his paintings look as though he was working with a microscope and a telescope at the same time.

The so-called *Arnolfini Wedding*—it may not be a wedding at all—is Jan van Eyck's most endearing portrait. Giovanni Arnolfini, the Medici representative in Bruges, and his wife, both extravagantly dressed in furs and silks, are depicted in their bedroom. Arnolfini, a grave young man with an olive-shaped face, wears a huge black felt or fur hat, a symbol of his wealth and power. He clasps his wife's right hand in his left, holding his right hand at his chest in a gesture of greeting or benediction.

In the bull's-eye mirror (surrounded by a wooden frame with ten spokes and ten tiny circular glass roundels in which are painted scenes of Christ's Passion) are reflected two diminutive men dressed in courtly garments, one in blue and the second in crimson. The man in blue, who is about to enter the chamber, is thought to be Jan van Eyck himself, as an inscription over the mirror states in Latin (*Johannes de Eyck fuit hic*—Jan van Eyck was here). In the brass chandelier there is a lighted candle on the man's side; on the woman's there is a candle that has gone out.

The room is illuminated by natural light that streams in from a window through which a tiny slice of cityscape is visible. Some scholars claim that many of the miraculously rendered objects of daily life are also Christian symbols: The couple's wooden shoes may indicate that the unshod pair is standing on holy ground; the single lighted candle in the brass chandelier may indicate the Holy Spirit; the fluffy dog at Signora Arnolfini's feet may symbolize fidelity.

A new theory about this superb painting holds that Giovanna di Nicolao, Arnolfini's wife, had died in childbirth by the time Van Eyck signed the double portrait in 1434. The carpet in front of the bed suggests this: At the time it was customary to lay a carpet at the side of the bed of a departed mother or wife. The figure of Saint Margaret in prayer could be taken as interceding for the soul of the departed, and the carved wooden monster above the woman's hand might also refer to her death.

This is just one of many debates that arise each year about Jan van Eyck and his work. Others involve a mysterious older brother, Hubert, who may or may not have collaborated on Van Eyck's most magnificent work, known as the Ghent Altarpiece—a two-story-high triptych that is considered one of the finest masterpieces ever created. What is never debated is Jan van Eyck's place among the greatest artists.

Fra Angelico (Giovanni da Fiesole), 1400–55, Italian
The Deposition, 1440
Tempera on wood, 74 × 70 1/2 in (185 × 176 cm)
San Marco Museum, Florence, Italy

One of the prime glories of Florence is the Museo di San Marco, the former Dominican convent designed by the architect Michelozzo. The museum is small, intimate, and not perpetually crowded like the rest of the city's art treasures. The convent is also satisfyingly humble.

The series of glistening frescoes on the walls of the chapter house, the entrances to twenty monks' cells, and the cloister are in stark contrast to their humble surroundings. These masterpieces, which gleam with confident beauty and profound religious feeling, were created by the monk Giovanni da Fiesole, better known as Fra Angelico, "Angelic Brother." He was also called *Beato,* or "Blessed," by his fellow monks because of the calm purity of his works.

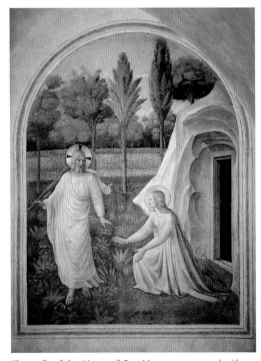

The walls of the Museo di San Marco are covered with Fra Angelico's religious works.

The large *Deposition* is one of Fra Angelico's finest early works. The brilliant colors may indicate that he started off as an illuminator. The work is a prime example of the elegant late Gothic style, with its typical attenuated figures. Fra Angelico had yet to come under the spell of the other two giants of the early Florentine Renaissance, Masaccio and Donatello.

Christ's dead body is being removed from the cross, and Mary Magdalene tenderly kisses the Messiah's feet. The grieving Madonna can be seen just behind Mary. Directly above the scene, in three triangular spandrels, we see the Resurrection flanked by the scene of *Noli me tangere* (when Christ warns Mary not to touch his body) to the left and the Three Marys at the empty tomb.

The people who attend the Deposition are depicted as slender and straight as the painted and gilded columnar figures carved on a Gothic cathedral. Every detail of physiognomy and dress is impeccably portrayed. Especially striking are the two landscapes: on the left the view of a fantasy Jerusalem, and on the right the desolate wilderness surrounding Golgotha.

Fra Angelico became a Dominican monk at the age of eighteen and was renowned not only for his life of piety but for the accomplishment of his works. He was also an able administrator and was appointed to high posts in the convent. He died in Fiesole in 1455.

A number of his works are in the United States, the best of which is an exquisite panel in the Kimbell Art Museum in Fort Worth, Texas. It shows the magician Hermogenes being freed by Saint James from a gaggle of loathsome devils whom the magician had conjured up before becoming a Christian.

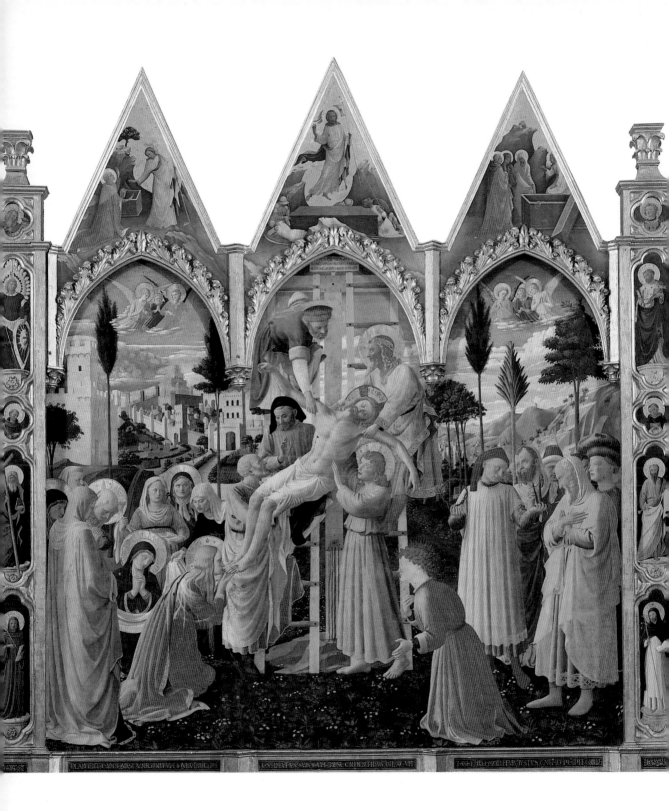

Uccello (Paolo di Dono), 1397–1475, Italian
The Battle of San Romano, ca. 1438–40
Tempera on wood, 72 × 125 in (182 × 320 cm)
National Gallery, London, England

Paolo Uccello was one of many child prodigies spawned by the Renaissance. When he was ten years old he was apprenticed to the incomparable Lorenzo Ghiberti (creator of the *Gates of Paradise* adorning the Baptistery in Florence). At eighteen

Uccello was admitted into the painters' union of the day. None of his earliest works have survived. His first frescoes, scenes from the Old Testament, can still be seen (despite their bad condition) in Florence's Santa Maria Novella, in a niche in

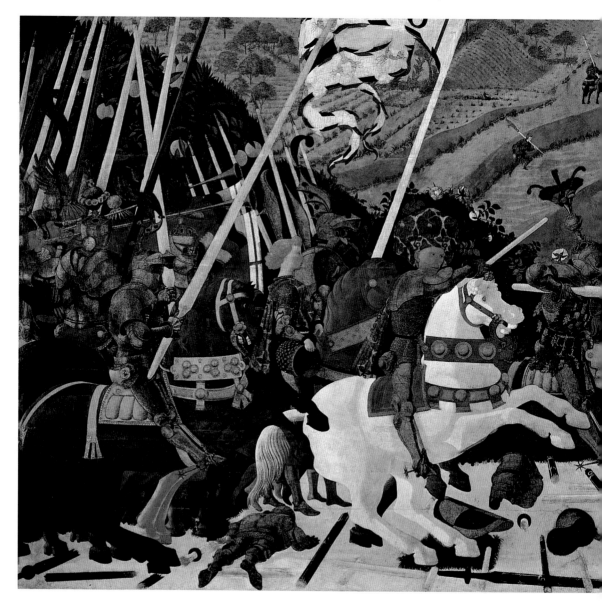

the Green Cloister, named for the color of Uccello's underpainting.

Uccello was forty-eight years old when he painted three enormous temperas depicting—in a somewhat fantastical, almost Hollywood fashion—the Battle of San Romano, which concluded with the rout of the Sienese army by the Florentines in 1431. The trio was commissioned to hang in Lorenzo de' Medici's bedchamber so that every night the victor could savor how his troops had humiliated the enemy (Lorenzo was that kind of guy). The canvases are in relatively good condition and are displayed in London's National Gallery, the Uffizi, and the Louvre. The three have not been shown together in centuries, and if there ever was a miniblockbuster worth assembling, this is it. When I was director of the Metropolitan Museum, I tried to bring them together, but I received puzzled smiles and polite turn-downs.

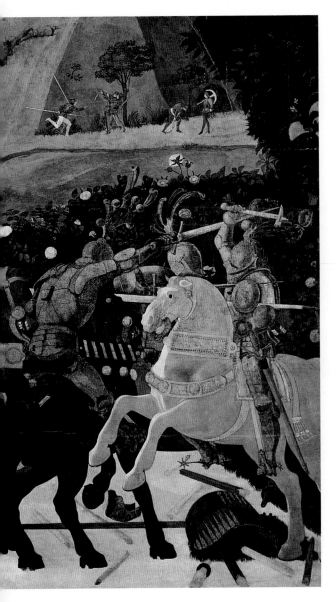

One of the many innovations of the Italian Renaissance was the manipulation of perspective and space on a flat surface. Uccello was obsessed with perspective, of which he created stunning examples. Records tell of people recoiling in shock when seeing his paintings because their perspective and depth of field seemed so true to life.

The scene shows the dashing mercenary Nicola da Tolentino—in silver armor, wearing an eye-catching red hat, and astride a pure white steed—leading the final charge against the Sienese. The upright lances symbolize both the moral rectitude of the Florentine troops and their indomitable power. Behind Nicola lies a fallen Sienese, shown in startling foreshortening. Before him are some splendid details of broken lances and bits and pieces of armor.

The picture possesses a cool classical pallor that adds considerable dignity to the scene, giving it the aura of some ancient Greek painted relief. Particularly effective are the detailed armor and weaponry, the colorful billowing banners atop the lances, and scenes in the far-off distance, where foot soldiers take off with two knights and other troopers aim and draw their crossbows in a futile attempt to save the day.

Of the thousands of works of art depicting knights in armor slamming away at one another, this one and its two companions are among the best. You can virtually hear the din of battle, the joyful shouts—"Onward! Onward!"—of the winners and the sighs and cries of the losers.

Hugo van der Goes, ?–1482, Flemish
Portinari Altarpiece (Adoration of the Shepherds), ca. 1476
Oil on wood, 100 × 233 in (253 × 586 cm)
Uffizi, Florence, Italy

The Northern Renaissance painter Hugo van der Goes was considered in his day to be the heir to the genius Jan van Eyck. No one knows where Van der Goes was born, but he showed up in Ghent and was admitted into the artists' union in 1467. His works were revered, and he received an enviable number of commissions in Flanders, Spain, and Italy. A jack-of-all-trades, his works included a heraldic shield and a processional banner for Charles the Bold. He was deeply religious and entered a monastery as a lay brother in 1478.

Van der Goes's most exciting work is the *Portinari Altarpiece*, commissioned for a Florentine church by Tommaso Portinari, the Medici agent in Brussels. The huge, jewel-like piece depicts the Nativity and the Adoration of the Shepherds as an operatic affair full of verve and penetrating notes. Joseph appears as a vigorous player, not a sleepy old man. Fifteen beautifully idealized angels, representing the Fifteen Joys of the Virgin, hover above. Three crouching peasants adore the child, who lies on the cold ground, surrounded by celestial

light. These shepherds are not idealized at all; they seem to have just come in from their flocks.

Tommaso Portinari himself appears with his young sons on the left panel, accompanied by Saints Abbate and Thomas. On the right panel, we see Tommaso's wife, Maria, and daughter, accompanied by Saint Margaret and Mary Magdalene. (If you think Madame Arnolfini looks pregnant—see page 98—note the similar effect of the Magdalene's dress.)

The triptych's backgrounds are almost as fascinating as the dominant theme. In the distance in the main panel, an angel proclaims Christ's birth; Joseph leads Mary toward Bethlehem, donkey in tow, on the right. But the most striking feature—which overwhelmed Florentine artists when it was exhibited and surely

had a stylistic influence on Florentine painting—is the depiction of space, which is both intimate and vast.

When I saw the painting on my first visit to the Uffizi in the fifties, I was not only astounded to find it among the Italian Renaissance works but thoroughly taken by its scope and power, and by the intricacy of its details. Knowing Van der Goes and the custom of the Northern painters you can be sure that every detail has a symbolic meaning. For example, a lily (which symbolizes Christ) stands taller than a sheaf of wheat, the symbol of the Old Testament—implying that the new law has replaced the old.

Hugo van der Goes suffered a mental breakdown in 1481 and died the following year in the monastery where he lived.

Leonardo da Vinci, 1452–1519, Italian
Woman with an Ermine, 1483–90
Oil on wood, 21 × 15¹/₂ in (53.4 × 39.3 cm)
Czartoryski Museum, Krakow, Poland

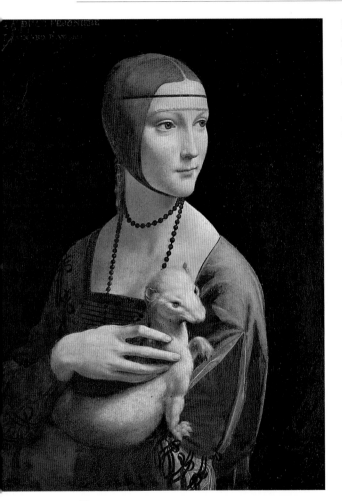

The illegitimate son of a notary and a peasant woman, Leonardo da Vinci showed his ability early and at fifteen was sent to the workshop of the popular Florentine painter and sculptor Andrea del Verrochio. He soon surpassed his master and became a legend for a wide variety of accomplishments—drawing, painting, sculpture, and the design of massive fortifications, especially for the Duke of Milan, few of which were ever constructed. His sketchbooks, written in his mysterious, left-handed mirror writing, reveal the incredibly wide interests of this artistic genius—from pristine drawings and grotesque caricatures to gamboling horses, helicopterlike flying machines, and studies of ocean waves.

Leonardo was famed for his versatility. He was a master of several types of art (easel paintings, frescoes, altarpieces) as well as science. But he is revered for his drawings; some consider him the best draftsman of all time. Unfortunately many of Leonardo's works have not survived or have deteriorated badly, including *The Last Supper* in the chapel of Santa Maria delle Grazie in Milan, which started to peel off the wall even during his lifetime. Leonardo left all too many works unfinished; though fragmentary, they still possess immense power.

One of his finest surviving works is *Woman with an Ermine.* The name of the model is unknown. The ancient Greek word for "ermine" is *gale.* This may be an obscure reference to Cecilia Gallerani, the mistress of Ludovico Sforza of Milan, Leonardo's prime patron between 1482 and 1497. Considered one of the most charming women of the Milanese court, she became Ludovico's mistress at sixteen and bore him a child. When she left him to marry, he granted her an entire town. Or the woman may have been meant to be Poppaea, Nero's evil mistress, who was described elsewhere with the malevolent gaze we see here.

Leonardo has captured his subject with intense focus, made sharper by the use of a plain black background. The young woman and her pet ermine stare at something off to the right with strangely similar expressions. At first glance they seem innocent, even pleasant. But on further scrutiny you sense something unsettling and distinctly unpleasant, as if each is waiting to sink claws into you. We can't turn away—the artist and the image compel us to keep looking.

Piero di Cosimo, ca. 1462–1521, Italian
Vulcan and Aeolus, ca. 1490
Oil and tempera on canvas, 62 × 66 in (155.5 × 166.5 cm)
National Gallery of Canada, Ottawa

Though not exactly a household name today, Cosimo was a talented and innovative artist who created some intriguing mythological stunners. In *Vulcan and Aeolus*, Vulcan, the god of fire and the inventor of the forge, hammers away while a grizzled Aeolus, god of the winds, carries on a spirited conversation with a young man on a white horse that looks like a stuffed toy. A hint of comedic subtext makes the work more compelling. Will one builder whack the other with the beam he's holding? Will the horse collapse?

All the High Renaissance hallmarks are here: an intense attention to anatomy, unusual posturing of the human figure, references to works of classical antiquity (the man on the right about to kiss his baby is based on an ancient statue that is today in the Vatican), one-point perspective, and humanistic subject matter. Some scholars believe that the work represents the dawn of civilization.

In Giorgio Vasari's *Lives of the Painters*, Cosimo comes off as an eccentric. If the less than entirely unreliable Vasari can be believed, the artist lived exclusively on hard-boiled eggs, "which he cooked while he was boiling his glue" to save fuel. No wonder that we see his sense of humor in his work.

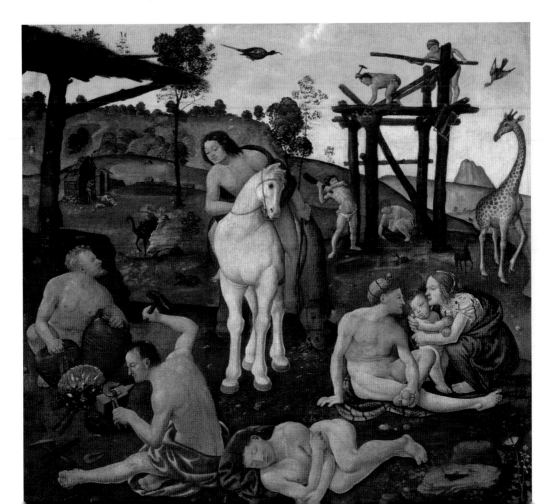

Sandro Botticelli, 1445–1510, Italian

Primavera, 1485
Tempera on wood, 126 × 82 in (314 × 203 cm)
Uffizi, Florence, Italy

The Mystic Nativity, 1500
Tempera on canvas, 43 × 30 in (108.6 × 74.9 cm)
National Gallery, London, England

No artist of Italy's High Renaissance was as visually lyrical as Sandro Botticelli; his works convey a surpassing sweetness. Botticelli was born in Florence and lived there his entire life. He studied under the best, Filippo Lippi and Andrea del Verrochio, but his distinctive style was always more linear than the sculptural style of his Renaissance teachers and contemporaries. You can always spot Botticelli by his spectacular women. They are radiantly beautiful, with high cheekbones, sparkling wide eyes, flowing tresses—all the features of today's supermodels.

In 1485 Botticelli received a commission to paint two large oils for a lavish villa near Florence belonging to Lorenzo di Pierfrancesco de' Medici, a humanist poet and second cousin to Lorenzo de' Medici. The paintings, *The Birth of Venus* and *Primavera* (*Spring*), may have been wedding gifts from Lorenzo.

Among a plethora of theories about what *Primavera* means, the most accepted one is that it's an allegory based on writings of Ovid and Lucretius, and that its message is that life, beauty, and knowledge exist forever under the rule of love. The best way to read the painting is from right to left. As spring arrives, Zephyr breathes life into a frigid Flora. The Three Graces dance to celebrate, and Mercury banishes all vestiges of winter clouds. At the center, Venus, her son Cupid hovering above, unifies all the elements in the rapidly greening world with the force of love.

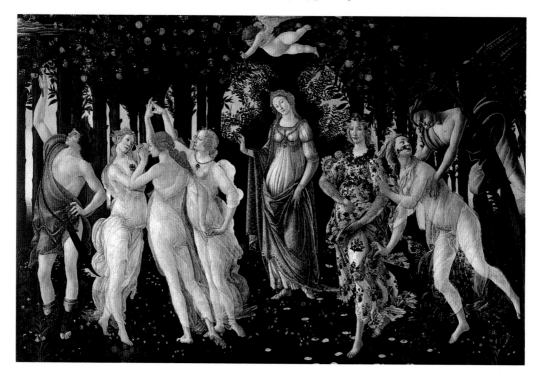

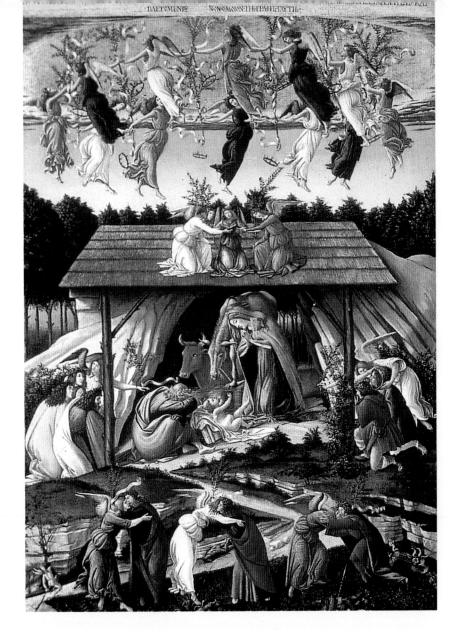

In the 1490s Florence was overtaken by religious turmoil. A fundamentalist priest, Girolamo Savonarola, railed against the excesses of the Medici and the general decadence of contemporary life and preached in favor of purity and rectitude, until he was burned at the stake in Florence in 1498. Botticelli was deeply influenced by Savonarola, and some of his late works allude to the preacher's radical religious views.

Savonarola's favorite saying was: "Repent of what you have done, distance yourself from the Demon, let yourself be won over by the angels." *The Mystic*

Nativity, populated by a host of angels, is clearly inspired by Savonarola. A Greek inscription predicts the destruction of the present, corrupt world and the birth of a new, purer one.

In the center of the painting, there's an exceptionally sweet Nativity. In the foreground Jacob wrestles the angel. Five devils, who, we presume, are about to be buried forever, flee the contest. Despite the apocalyptic inscription and the dour colors, the glowing angels and magnificent light emanating from the grotto are pure Botticellian lyricism.

Raphael (Raffaello Sanzio), 1483–1520, Italian
The Burning of the Borgo, 1514–17
Fresco, 96 × 72 in (240 × 180 cm)
Stanza dell'Incendio, Vatican Palace

Compared with Michelangelo, Raphael has always had something of a bum rap. Vasari, who wrote the influential *Lives of the Painters* in the sixteenth century, was persuaded by an old and cranky Michelangelo to rewrite Raphael's life in his second edition and throw in some zingers. One: that Michelangelo possessed a sublime intuitive faculty, whereas Raphael learned his art not from nature but from long study. Another: that Raphael's style was formed by copying Leonardo and by seeing Michelangelo's *Battle of Cascina* and his unfinished Sistine ceiling.

Contrary to this unfair criticism, Raphael painted from the heart. Although he admired Leonardo and although his figures became slightly more robust and "contrapostic" (they twisted and turned more vigorously) after he saw Michelangelo's work, he had a style of his own and was a true genius. In many ways Raphael possessed a depth and a breadth of vision that even Michelangelo lacked. An architect as well as a painter, Raphael created complicated works that are diverse, subtle, dramatic, humorous, and fanciful.

While Michelangelo was painting the Sistine Chapel (see pages 112–13), Raphael was producing his first glorious frescoes for Pope Julius II in the private papal apartments, called the Stanze della Segnatura. One of these is in the Stanza dell'Incendio, or the "Room of the Burning" of 1514. The terrifying action takes place on what seems like a stage, with a variety of figures fleeing a fire or trying vainly to gather water to extinguish it. It is so classical in style that one can imagine looking at some painted ancient Greek tympanum. Raphael, well acquainted with antiquity, had been appointed superintendent of ancient monuments in Rome. Thus he saw every antiquity just as it had been unearthed, and he deftly translated these ancient marbles and paintings into his works. In the *Incendio* he displays the row of columns that had recently been discovered in the Forum.

On the left a muscular youth carries an old man from the flames—a visual recreation of a theme from Virgil's *Aeneid*: Aeneas carrying his father, Anchises, from burning Troy. The frightened, athletic nude figure letting himself down from the wall is not directly from the antique yet is imbued with all the force and movement of classical art. On the right a marvelous chain of people struggles for water.

In the center of the drama with her back to the viewer is a woman in yellow who throws out her arms beseeching someone to aid the stricken citizens. Follow her right arm up the stairs along another human chain to the balcony, and you will find the hero of *The Burning of the Borgo*. It is Pope Leo IV, who in the ninth century is said to have quenched a fire threatening the Vatican with a gesture of benediction.

Raphael, another child prodigy of the Renaissance, was born in Urbino, a city known for its learning and fine art. He apprenticed in Perugia when he was seventeen. One story has it that he ran out of money on the way to Perugia and "paid" his inn bill by painting coins on a panel in striking trompe-l'oeil, leaving it for an astonished and delighted innkeeper. By the autumn of 1504 Raphael had arrived in Florence, where he was influenced by Leonardo and Michelangelo. In 1508 he was called to Rome by the city's master builder, Pope Julius II. He spent the last twelve years of his short life there.

What a career! He painted the papal apartments for two popes; *The Triumph of Galatea*, a series of dynamic mythological frescoes in the Villa Farnesina; a penetrating portrait in the Louvre of the humanist Baldessare Castiglione; the gripping psychological study of *Pope Leo X with Two Cardinals* in the Uffizi; and a series of magical and gorgeous Madonnas, two sublime examples of which are in Washington's National Gallery.

If I had my way, I'd look at a work by the divine Raphael every day of my life. I would find myself daily uplifted and transported into a sublime state. I thoroughly concur with the sentiments of the great art-historical connoisseurs of the nineteenth century, Sir Joseph Archer Crowe and Giovanni Battista Cavalcaselle, who wrote, "Raphael! At the mere mention of this magic name our whole being seems spellbound. Wonder, delight, awe take possession of our souls, and throw us into a whirl of contending emotions."

Raphael was working on his grand *Transfiguration* when, at the tender age of thirty-seven, he fell ill and died. There was some talk that the pope would make him a cardinal, so beloved he was by the Vatican. He was buried in Rome's Pantheon, where his tomb can be seen today.

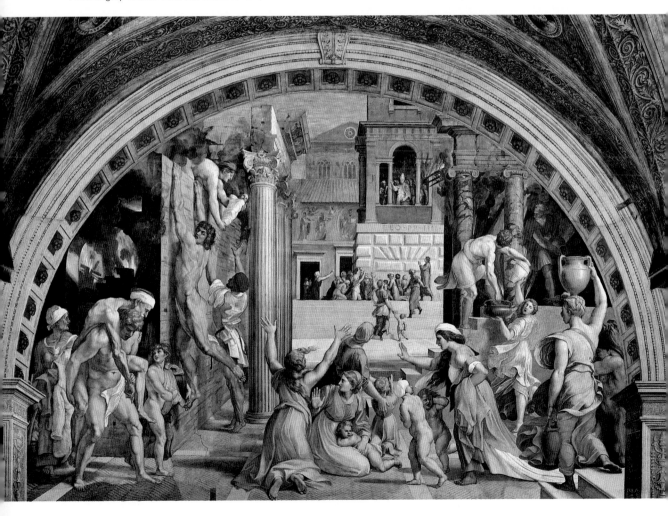

Michelangelo Buonarroti, 1475–1564, Italian
The Creation of Adam (detail from ceiling), 1508–12
Fresco, approx. 224 × 110 in (560 x 265 cm)
Sistine Chapel, Vatican City

When the Sistine Chapel was being washed in the 1980s, I was invited to go up in a tiny elevator to the scaffolding just under the shallow vault to inspect the restoration of Michelangelo's frescoes. The process was both benign and easy—a swipe of my delicate sponge immediately revealed pristine surfaces of the ceiling and dazzling colors that had been obscured by coal dust for centuries.

I also saw the *giornata* ("day's work") on several of the sections. A *giornata* is the exact amount of wet *intonaco* (plaster) applied to the prepared ceiling that the artist could paint before it dried out, for the plaster must be wet while painting a true fresco (*fresco* means "fresh"). Michelangelo, never having done a fresco before the Sistine ceiling, was learning as he went along. Only he could have created a work of such grace and ferocity (or, to use the Italian word, *terribilità*) on his first try.

The Creation of Adam is the most memorable section of the ceiling. God the Father, supported by a group of *putti* and an angel, hovers just above the magnificent figure of the reclining Adam. God's right

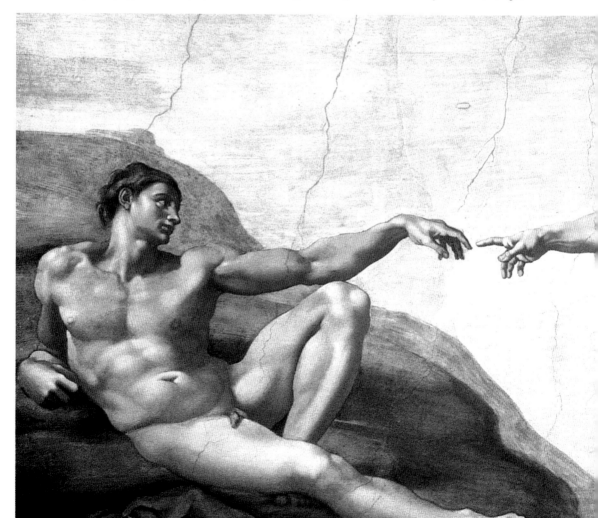

index finger is just about to touch Adam's left. Once the finger is touched, the spark of life will surge through Adam's muscular body, and human life will be energized. There is simply nothing equal to the poetry, tenderness, suppressed energy, and beauty of *The Creation of Adam* in all of Western art.

The Sistine Chapel, built in the late fifteenth century, is approximately 120 by 40 feet and 60 feet high. The vault is very flat—a mere six inches deep—but seems to soar because Michelangelo painted his works in a deep perspective. The walls, painted with stunning masterworks by the likes of Botticelli, Perugino, and Luca Signorelli, are divided into three epochs—before Moses received the Ten Commandments, the interlude between Moses and Christ's birth, and the Common Era thereafter. The chapel is used for papal conclaves

and ceremonies, and when there's an event, the walls are covered by Raphael's tapestries depicting scenes from the Gospels.

In 1508 Michelangelo was commissioned to paint the ceiling frescoes by Pope Julius II; he completed them in 1512. He originally signed on to paint only the twelve apostles, but he bullied his way to create a Christian drama with more than three thousand players ranging from ancient sibyls to prophets and characters from Genesis. After he completed *The Last Judgment,* with its regiment of nudes, Michelangelo was accused of "intolerable obscenity." A law ordained that the genitals be covered; fortunately *The Creation of Adam* was spared this ridiculous depredation, and the fresco is as pure and dynamic as the day it was finished.

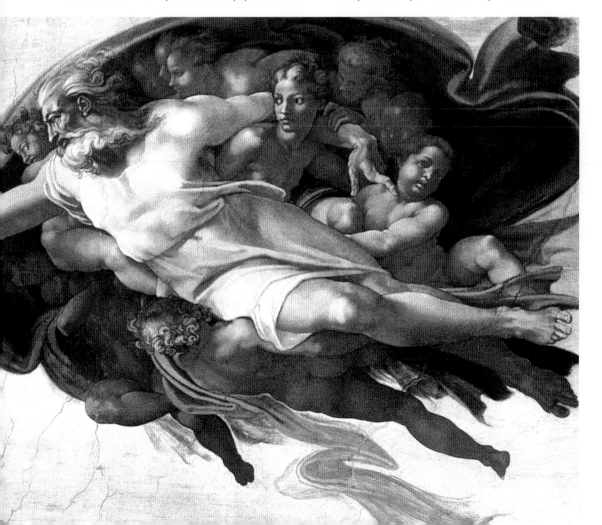

Hans Holbein, 1497–1543, Swiss
The Ambassadors, 1533
Oil on wood, 81$\frac{1}{2}$ × 82$\frac{1}{2}$ in (207 × 209.5 cm)
National Gallery, London, England

Hans Holbein studied under his father until he was eighteen, at which point he went to Basel, then the art capital of Europe. In Basel he was befriended by the humanist Erasmus of Rotterdam and by Martin Luther. Both were deeply enmeshed in the conflicts of the Counter-Reformation, and both asked Holbein to illustrate their treatises on reforming the church. Erasmus introduced Holbein to the great philosopher Sir Thomas More, who introduced the painter to the English court. Happy to leave the turmoil of the Reformation, the young painter and engraver went to London, where he eventually became court painter to Henry VIII. The job must have been fabulous, because Holbein abandoned his wife and children for it.

Anyone who's had the good fortune to see some of the hundred surviving drawings, paintings, and miniatures of luminaries of Henry's grandiose court—especially those from the collection of Queen Elizabeth II—will know that Holbein unerringly flattered his subjects. There's not a crooked nose, blemish, or frizzy hair in any of the startlingly realistic portraits. However, the sheer beauty and meticulousness of the works transcend all idealization. Holbein's portrait of Henry, according to a contemporary account, was painted life-size so that it seems to "live as if it moved its head and limbs."

The two characters in *The Ambassadors* are Jean de Dinteville, twenty-nine, French ambassador to England in 1533 (on the left), and his friend Georges de Selve, twenty-five, bishop of Lavaur, who was French ambassador to the Holy See. From the splendidly painted implements on the tables we can see that these young men are among the most educated, progressive, and brilliant men of their time.

The painting is loaded with symbolic meanings. In the upper left corner, barely visible, is a silver crucifix. Scholars have interpreted this to be a reminder that spirituality is above human experience and materialism. On the lower table the lute has a broken string that may signify religious discord; the open book, a Lutheran hymnal, may be a plea for Christian harmony.

The most intriguing parts of this endlessly puzzling work are the floor and the strange object splashed across it at an odd angle. The pattern of the tiles is based on the floor in the sanctuary of Westminster Abbey, and according to the inscription in the Abbey, signifies the macrocosm of the universe. The long gray slash is a skull that can been seen clearly only by means of a distorting mirror which will straighten out the image. (The skull can also be seen correctly if you peer down from the upper left of the painting.) The classic interpretation of the skull is as a *memento mori*, a reminder that death is going to grab us all—even finely dressed, brilliant young strivers like these.

Holbein worked endlessly for the demanding Henry and produced everything on time, aware, no doubt, of the king's anger threshold. He designed the king's state robes and made drawings that were the basis of all kinds of items used by the royal household, from buttons to bridles to bookbindings. In 1539, when Henry was thinking of marrying Anne of Cleves, he sent Holbein to paint her portrait. Henry was so taken with the portrait that he married the woman sight unseen, but he was less happy with the real thing—they divorced after six months. In 1543 Holbein was in London working on another portrait of the king when he died, a victim of the plague.

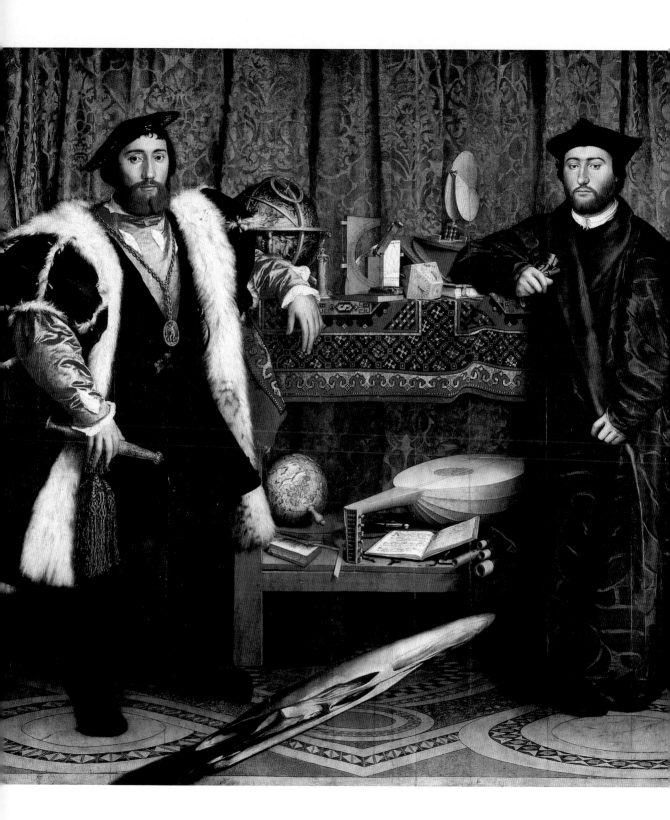

Hieronymus Bosch, 1450–1516, Flemish
Garden of Earthly Delights, 1504
Oil on wood; central panel: 86^1/$_2$ × 76^1/$_2$ in (220 × 195 cm); wings: 86^1/$_2$ × 38^3/$_4$ in (220 × 97 cm)
Prado, Madrid, Spain

Hieronymus Bosch was a genius of the second generation of the Northern Renaissance who lived his entire life in 's Hertogenbosch, a prosperous town in Holland near the Belgian border. He is famous for enigmatic altarpieces illustrating religious subjects and populated by demons and hybrid animals and birds.

We can only make a stab at the meaning of many of Bosch's fantasies. Generally his images show an obsession with the penalties for weakness and sin, principally God's damnation and hell as punishment for human folly. Yet it is also clear that many of his sweet-sour creatures are simply strange and wondrous shapes that happen to have gripped the artist's fancy (and have influenced the work of artists ever since).

Life in late medieval times was one of striking contrasts, both religious and superstitious. It was a time when people believed in alchemists and witches and things that went bump in the night; and in fact, there was reason to be pessimistic: plagues, terror, and lawlessness governed. The devil came to town on a regular basis to snatch souls, most times successfully. The only hope was in a merciful redeemer who might save the repentant sinner.

The technique Bosch used in this world-famous triptych is *alla prima*, the free application of paint to a preliminary ground of light brown. The style is a miraculous realism in which the tiniest details are completely finished. You can spend hours poring over this work and still find something new.

The picture has four separate episodes. When closed, the triptych depicts the third day of Creation. When opened, it reveals three scenes with a common horizon line. On the left side are Adam and Eve in the Garden of Eden. The square center panel represents the Garden of Earthly Delights, depicting primitive man and woman in a deceptively sweet landscape. But Bosch's garden is a false paradise, the world after the Fall, when mankind turned from the fountain of life to the fountain of the flesh.

The most exciting panel is the Last Judgment and hell, a black, icy, and fiery place, the very image of perpetual winter where living nature has died, innocence is gone, and the music of the spheres has turned into shrieks of agony. It is from this eternally fascinating scene of torture and eternal pain that our details have been chosen.

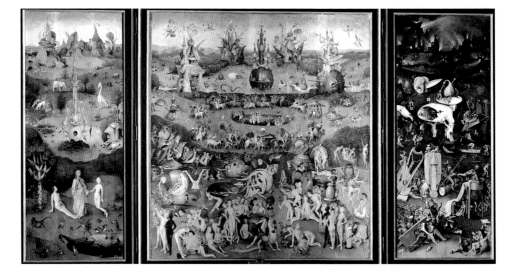

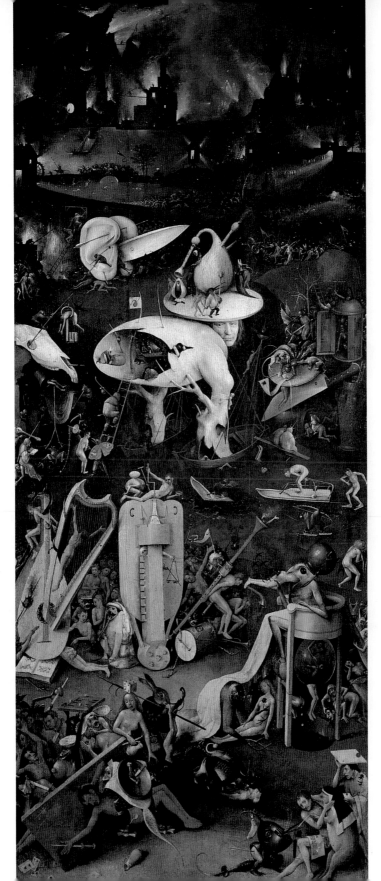

Opposite: the complete triptych.

Left: hell, the right panel.

Titian (Tiziano Vecello), ca. 1495–1579, Italian
The Rape of Europa, ca. 1575–80
Oil on canvas, 71 × 82 in (178 × 205 cm)
Isabella Stewart Gardner Museum, Boston, Massachusetts

In 1990 thieves wearing local police uniforms broke into the grand Isabella Stewart Gardner Museum and made off with thirteen major pictures including a fine early Rembrandt. Thank goodness they didn't have the time—or perhaps the smarts—to cut out of its frame the Gardner's best work (and perhaps the best old master in the United States) Titian's *Rape of Europa*. None of the stolen works has ever showed up again, and it is presumed that the thieves destroyed their loot.

Titian, a great master of the Italian High Renaissance, is known as the shrewdest practitioner of the artistic techniques of the time—monumental figures twisting and turning in action, exacting perspective, and the deft use of ancient Greek and Roman models. He enhanced his works with shimmering colors painted in myriad layers called glazes. Titian imbued every one of his wondrous creations with the silver sheen of Venice's waters and the breathtaking pink-and-yellow afterglow of its incomparable sunsets.

In his day Titian was a star in the artistic firmament, considered a strong rival of Michelangelo and Raphael. He was the portrait painter of choice for royal families throughout Europe, for whom he created acute character studies. His nudes were much in demand because few could paint flesh as voluptuously. His success as an artist was partly a result of longevity and high productivity; he arrived in Venice when he was still a child, worked with Bellini and Giorgione as a young man, and remained there until he died some eighty years later. More than six hundred paintings are attributed to him.

The Rape of Europa, painted for Philip II of Spain, illustrates the legend of Jupiter, who, after spotting Europa cavorting on a lonely beach with some handmaidens, transformed himself into a white bull. He enticed the young women and allowed Europa to crown him with a garland. He then seized her and started swimming away.

Europa's maidens look on in shock from the beach while two cupids shoot arrows of love. The snow white bull, his head adorned with Europa's garland, his eyes flashing with lust, churns out to sea bearing the half-naked maiden, whose emotions seem to have turned from fear to coquettish resignation. A third cupid on a huge silvery fish follows the couple closely, as if to ensure that this union will be consummated.

The highly charged scene is filled with sexual energy: Europa grasps the god's horn, and Jupiter's excitedly pulsating tail points to an obvious destination. The atmosphere of the painting is overpowering. It's as if Titian combined a sunset in the Grand Lagoon of Venice with the incandescence of the Alps. Europa's red cloak seems to have ignited the flames of the horizon skies.

Despite the breadth of technique—show a detail of the sky in an art-spotting test and the majority of us students of art would call it Renoir—Titian does not skimp on the details. When I first saw *The Rape of Europa*, I stood for a couple of hours digesting its impact and then relishing such small passages as the blue mountains, the trio of girls on shore, the glistening eye of the fish, and the snorting snout of the Olympian lover.

The Rape of Europa ingeniously combines a pagan celebration with a morality play. It is painted with some of the richest colors, hues, and glazes ever applied to canvas.

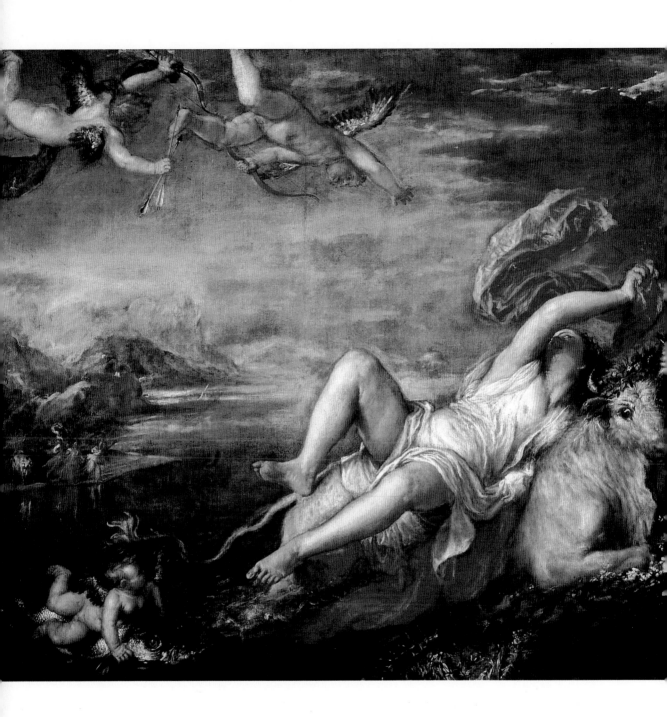

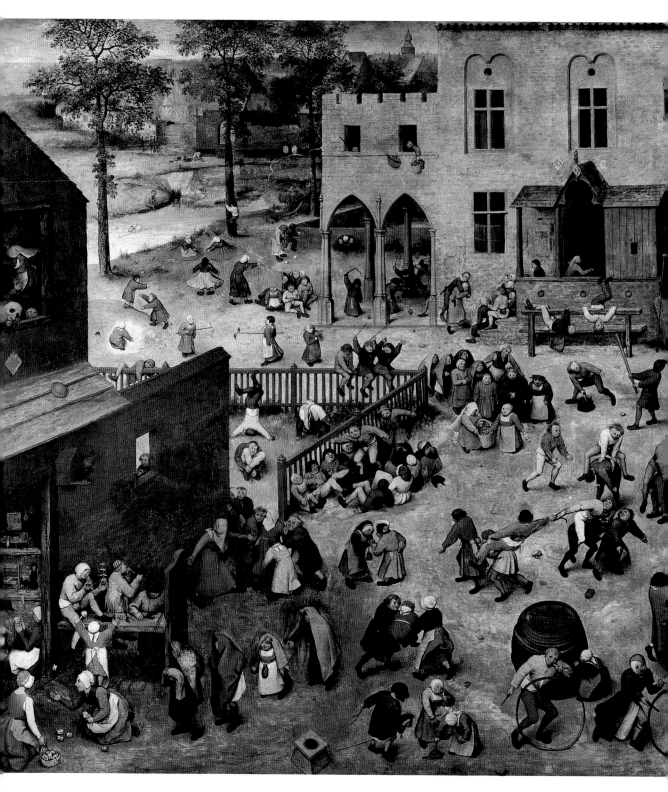

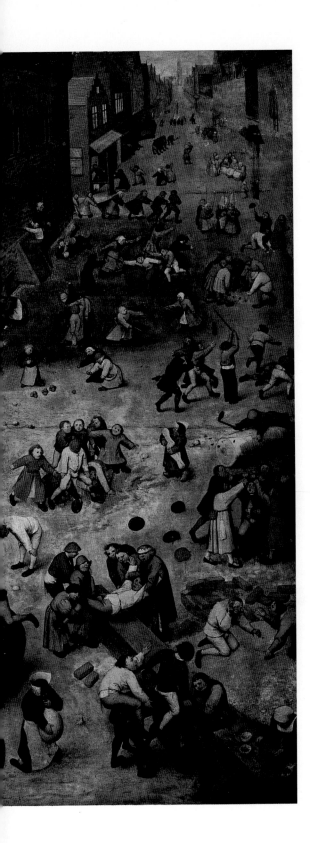

Pieter Brueghel, ca. 1525–69, Flemish
Games, 1560
Oil on wood,
47$\frac{1}{2}$ × 64$\frac{1}{2}$ in (118 × 161 cm)
Kunsthistorisches Museum, Vienna, Austria

Pieter Brueghel, called the Elder to distinguish him from his son Pieter, called the Younger (Jan—see page 126—was his younger son), was born in Breda in the lowlands and died in Brussels. He was admired by his contemporaries, who adored his work for its visual inventiveness and richness of technique and detail. Brueghel was a contemporary of Hieronymus Bosch (see page 116) and learned much from Albrecht Dürer, who worked one generation earlier.

In *Games* we look out a second-floor window in an upper-class section of a Dutch town to a spacious court and a long, straight street that recedes in sharp perspective to a gray church facade. We see an encyclopedia of fun in the early sixteenth century: In every part of the village folks of every age, even grownups, each distinctive in dress and look, dedicate themselves to playing at something—tellingly, something rather gentle. There are no signs of cruelty in Brueghel's gracious little world. It looks like a sugar-coated madhouse. The work is both a "learned" discourse on games and a parody of human life.

Some of the games survive, but there are many bygone amusements as well, sort of an *Our Town* world. As our eyes go down the long street, we find gentlemen rolling hoops, two athletes practicing gymnastic turns on a rail, a man on stilts, folks playing blindman's bluff, and others playing follow the leader.

Why did Brueghel visually catalog all these games? The only answer I can think of is that he strove to paint a complex townscape with every game then known, at least in Europe, so that everyone looking at it would ask, "Why did he do it?"

We know very little about this genius. Most of our knowledge of Brueghel comes from his works, which number fewer than fifty.

El Greco (Doménikos Theotokópoulos), ca. 1541–1614, Greek
The Burial of Count Orgaz, ca. 1586
Oil on canvas, 192 × 142 in (480 × 361 cm)
Church of San Tomé, Toledo, Spain

Doménikos Theotokópoulos, better known as El Greco, combined the long-dead *maniera Greca* style of Greek medieval icon painting with the soaring colors and energy of the High Renaissance to produce some of the most powerful works of all time. Born on the island of Crete, he first trained as a painter of anachronistic late-Byzantine icons, before traveling to Venice, where he studied with Tintoretto. In the mid-1570s he went to Spain, where he worked for the rest of his life, painting, among other things, royal commissions. It was in Spain that el Greco broke from the influence of Tintoretto and invented his unique style, which presented the world in dashing forms and sharp colors set off by jet black passages.

El Greco's figures are attenuated and twisting. His colors have a deliciously acrid afterglow. It's sometimes said, because of the severe distortion of his figures, that he suffered from astigmatism. Nonsense! His style was a deliberate effect; when he wanted to, he painted portraits of breathtaking realism and cunning insight.

His finest work, one I consider to be among the top religious works ever created, is a monumental masterpiece painted in the tiny chapel of a tiny church in Toledo. (The only frustrating aspect of viewing this treasure is that a small crowd can barely fit into the diminutive space.)

Count Orgaz was buried in the humble church in 1323 and left a massive bequest to the parish of San Tomé, but the officials in Toledo refused to honor it, preferring to spend the money on town projects instead. This unseemly situation lasted until Pastor Andres Nuñez sued for sole use of the revenues. In 1569 the chapel was heavily endowed and in 1586 Nuñez decided to redecorate. He asked the much-sought-after El Greco to paint his vision of the day on which the generous count was interred.

We see the grandee-donor, garbed in splendid black-and-gold parade armor, gently laid to rest. Saints, illustrious men, church fathers, choruses of angels, Christ, the Virgin, God Almighty, and hordes of the blessed surge over and around the grave site. The faces of the participants are powerful and sensitive. Their silk and satin garments are painted in dazzling trompe-l'oeil. Every passage is charged with electric energy. Particularly striking are the embroideries on the cope of the young Saint Stephen, on the left, who holds the count's legs. Saint Augustine, on the count's right, is clothed in a magnificent chasuble and miter. One could spend hours looking at the painted embroideries alone.

In the upper half of the monumental painting stands a group of sacred figures. Three-quarters of the way up, on the right, a brilliantly painted crowd from the Last Judgment floats in a thrillingly ambiguous space filled with dynamically undulating clouds and draperies so sharp they seem to crackle. The stunning black passages serve as perfect foils for the explosion of celestial color and divine light.

A meticulously painted inscription below the painting tells us: "When the priests were preparing to bury Orgaz—wonderful and extraordinary to behold—Saint Stephen and Saint Augustine descended from heaven and buried him with their own hands." Why? The inscription details the bequest (two sheep, sixteen hens, two skins of wine, eight hundred coins, and so on) and recounts the story of the town's negligence and the pastor's successful suit.

Bravo to you, Andres, and to the surpassing genius of Doménikos Theotokópoulos!

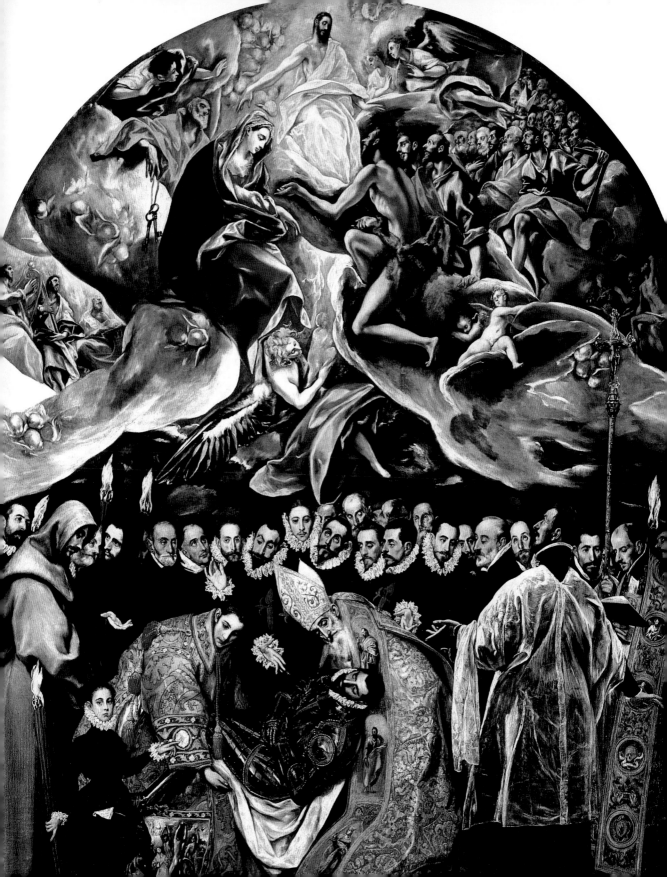

Michelangelo Merisi da Caravaggio, ca. 1573–1610, Italian

Bacchus, ca. 1597
Oil on canvas, 38 × 34 in (95 × 85 cm)
Uffizi, Florence, Italy

The Martyrdom of Saint Matthew, 1599–1600
Oil on canvas, 129 × 137 in (323 × 343 cm)
Contarelli Chapel, San Luigi dei Francesi, Rome, Italy

My favorite painter of all time is Michelangelo Merisi da Caravaggio. Born in Caravaggio, a town near Milan, he died at Porto Ercole of an illness contracted in jail after a wrongful arrest. He was one of the truly great innovators in all of Western art. He introduced into painting uncompromising realism and stunning—and sometimes violently theatrical—contrasts of light and shadow.

Caravaggio worked primarily in Rome near the Piazza Navona. Although he was a painter of matchless gifts, he was also a very nasty individual. He participated in the street life of Rome, drinking and brawling; he associated with prostitutes, female and male. He was jailed at least six times and released only through the intercession or protection of his patrons. Finally Caravaggio fled Rome to Sicily and Malta, after killing a victorious opponent in a tennis game.

Early in Caravaggio's career, his stark, never-before-seen realism titillated some members of the aristocracy, and he received a spate of commissions. The news of these radically fresh works spread quickly throughout Europe. Almost at once his style was widely copied.

One of Caravaggio's more provocative works depicts a tough, dissolute young man who shows

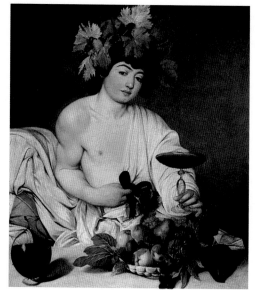

up in many of his paintings. In *Bacchus* (which was lost for hundreds of years and rediscovered in an Uffizi storeroom in 1917) Caravaggio accoutered his model (possibly a lover) in the trappings of the god of wine. The work displays a Caravaggesque hallmark: sharp contrast of light and dark (called *chiaroscuro* in Italian), as if there's a spotlight illuminating the scene. The modeling, especially of the drapery, is as steely and crisp as enamel.

Bacchus's face combines elements of street punk and male geisha, decadent yet sensuous, with lips on the edge of a pout, eyebrows plucked, cheeks rouged. He lolls on a magnificently painted bolster and holds his toga with his right hand (amusingly, his hands are deeply tanned) as he offers the viewer ruby red wine in a crystal goblet. A beautiful carafe sits on the floor to the left, and through its upper part, in a tour de force of realism, several folds of white cloth are visible. The splendid bowl of fruit in the foreground is one of the artist's favorite motifs—as good a still-life as ever existed. As usual some of the fruit has started to rot, just like the boy, a symbol perhaps of the life cycle.

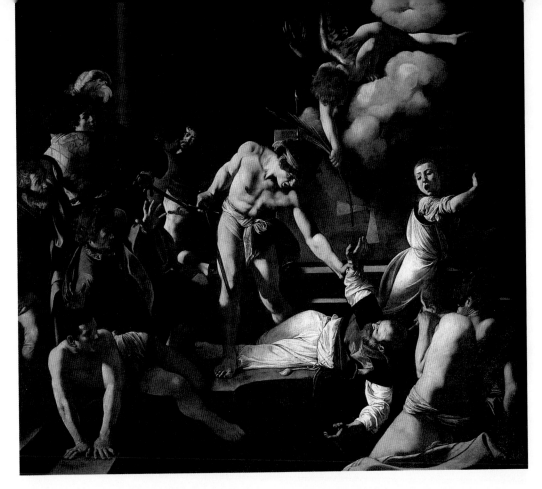

When he was just twenty-four years old, Caravaggio painted three canvases about Saint Matthew, including *The Martyrdom of Saint Matthew*, for the Contarelli Chapel in the French church of Rome, San Luigi dei Francesi. Contarelli had left funds and detailed instructions about the content of the paintings in his will; this major commission was given to the young Caravaggio by Contarelli's executor after several contracts with more traditional painters ended up in litigation. *The Martyrdom* appears on the right wall of the chapel, lit from the left, as if receiving natural light from a window behind the altar.

The murder of Matthew takes place in the brilliantly lighted center of the canvas, on the steps of a church bearing a Maltese cross. Similarly, the entire composition is organized in the shape of a Maltese cross, tilted slightly to the left. The composition serves as an engine of artistic energy. The athletic killer, clad in a tightly painted breechcloth, has just slipped his sword out of the evangelist's chest. The saint's blood, as vivid as Chinese lacquer, spurts like an incarnadine fountain. Matthew has fallen back and, dying, reaches up toward the palm of martyrdom held by an angel. Like ripples from a stone falling into still water, a crowd flees in horror from the grisly murder. In the upper part of the throng is one highly illuminated face—that of Caravaggio himself.

Caravaggio was known not only for his bold and innovative use of light and shadow but also for the incomparable, realistic passages of drapery such as on Matthew's lower arm and on the shoulder of the fleeing boy. In all of Western art there's nothing that compares to the figure of the assassin, so beautiful and brutal at the same time. And in the art of all time nothing compares to the drama and power of this tumultuous work.

Jan "Velvet" Brueghel, 1568–1625, Flemish
Sight, 1618
Oil on wood, 26 × 43 ½ in (65 × 109 cm)
Prado, Madrid, Spain

Jan Brueghel was the second son of the great Pieter Brueghel the Elder (see page 120). He was nicknamed "Velvet" because of his glowing enamel-like paint surfaces and "Little Flower" because of his utter delight in painting flowers. He worked extensively for Peter Paul Rubens (see page 128). It seems that in all the works of that master, every flower of the tens of thousands was painted by

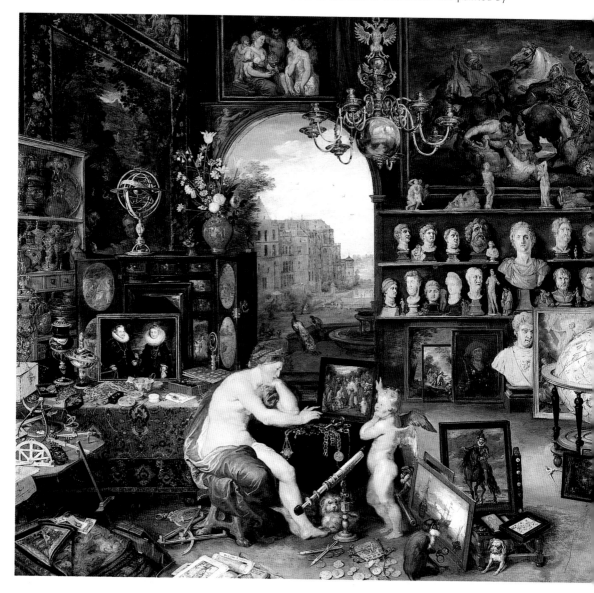

"Velvet" Brueghel. (He created, for instance, the amazing floral circle around Rubens's famous *Madonna in the Flower Wreath*.) His flower paintings, full of minutely detailed blossoms cascading out of baskets and vases, were markedly different from the formal floral arrangements that show up in most paintings of his time.

Brueghel was partial to painting in series—the seasons, vices and virtues, the senses, and the like.

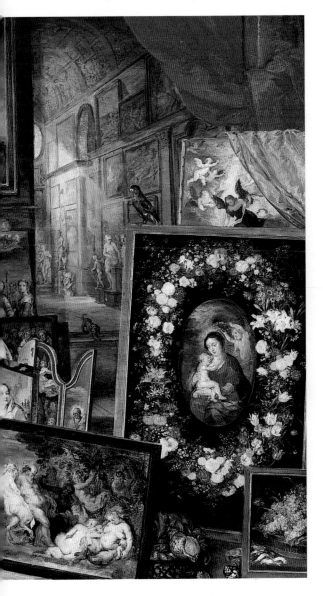

One of the best is the *Five Senses*. We've chosen *Sight* because it's loaded with delicious and hard-to-find details. The painting shows hundreds of works of sculpture, painting, and decorative arts plus dozens of scientific instruments. There appear to be nearly fifty symbols and allegories of sight in this complex painting.

The focal point of the work is a voluptuous nude connoisseur, painted by Rubens, who gazes intently at the details of a picture of *Christ Healing the Blind Man*. The work is presented to her by a cupid who stands beside a state-of-the-art telescope. Surrounding the nubile symbol of sight is a dazzling array of scientific tools all pertaining to improving sight—eyeglasses, microscopes, loupes, mapping equipment, and so forth.

The walls of this spacious chamber, so wonderfully lighted, are jammed with paintings and shelves laden with sculptures. The painting seems to be proclaiming that looking at art is the real and only way to see. We agree with that!

Rubens's world-famous *Madonna in the Flower Wreath* is on the far right, and below it there's another Rubens depicting a dead-drunk Bacchus (an appalling sight?). To the right of the splendid brass chandelier is still another Rubens of a lion fight. In the center of a group of Greek and Roman busts is one of Alexander the Great, who was said to have the ability to see forever.

Jan Brueghel was the most gifted painter of the Flemish school after Rubens. He received his first art lessons from his miniaturist grandmother. Brueghel traveled widely—to Italy, the Netherlands, and Prague—soaking up various artistic styles and working for a variety of patrons. In Milan he met the grand collector Saint Federico Borromeo. In the Pinacoteca Ambrosiana in Milan, which houses Borromeo's extraordinary art collection, is a breathtaking collection of Velvet Brueghel's finest works—luckily, they have never been restored.

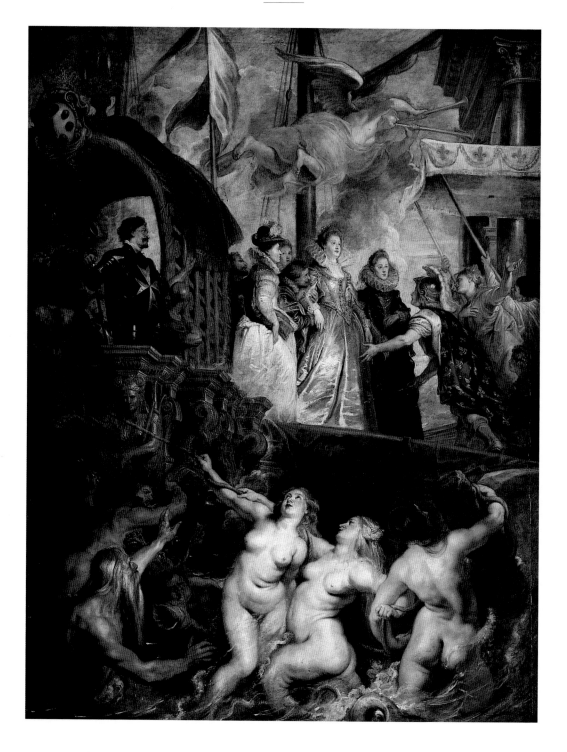

Peter Paul Rubens, 1577–1640, Flemish
The Debarkation of Marie de Medici at Marseilles, 1622–25
Oil on canvas, 155 × 116 in (394 × 295 cm)
Louvre, Paris, France

Peter Paul Rubens was a multifaceted genius—painter, courtier, diplomat, and even perhaps a part-time spy for Archduke Ferdinand and Archduchess Isabella of Spain. He so dazzled King Charles I by his efforts in the Spanish-English peace treaty of 1629 that he was knighted and commissioned to paint the exuberant ceiling of Whitehall Palace in London.

If called upon to choose a work that sums up his accomplishments, I'd point to one work in his monumental twenty-one-painting cycle in the Louvre depicting the life of Marie de Medici, the widow of French king Henry IV, made for the queen's audience hall in the Luxembourg Palace of Paris. All the theatricality, the sensuality, the bombast, the extraordinary feathery painting technique, the gorgeous color scheme, and even the touch of humor can be seen in this large canvas, which was worked on by the master and a platoon of assistants.

Marie de Medici stands in her shimmering silver satin dress of state on the deck of the vessel that has brought her to Marseilles. The figure in front of Marie, the symbol of France, garbed in a stunning blue steel casque and a cape covered with fleurs-de-lys, curtsies in honor of her arrival. On the left a Knight of Malta stands under the arch of the poop deck just beneath the Medici arms. Above Marie floats a rather incongruous figure of Fame—bare feet hanging out like jet engines—trumpeting Marie's moment of fame. Another trumpeter is on the left, honking away. Marie certainly gets no more than her fifteen minutes in this picture—because for all the trumpeting, the future queen of France and her retinue are upstaged by the sea creatures who have accompanied the vessel of state. On the lower left

an old Triton cheers her on as Neptune helps push the craft to the dock. A minion of Neptune blows a conch shell. Three voluptuous Sirens haul the boat to the mooring and, chaining themselves together by their beefy arms, secure it to the dock. These naiads are the epitome of Rubens's overblown and sheer magical fleshly style.

Rubens's background seems incongruous with the flesh he delighted in. His father was an ardently Calvinist Antwerp lawyer who fled to Germany in 1568 to escape religious persecution. After his death in 1587 the family returned to Antwerp, where Peter Paul was raised a Roman Catholic and received his early training as an artist. By the age of twenty-one he was a master painter whose aesthetic and religious outlook led him to Italy to complete his artistic education. In 1600 he went to Venice where he was greatly influenced by the reigning painters, especially Titian (see page 118). Rubens worked eight years as court painter to the Duke of Mantua. He also spent much time in Rome, where he painted a series of important altarpieces, all with outspoken Counter-Reformation themes. Once his reputation was established, Rubens returned to Antwerp in 1608 and became the dominant artistic figure in the Spanish Netherlands.

Rubens was responsible for a stupefying body of work—more than two thousand paintings, ranging from portraits and mythological subjects to deeply religious ones. During the final decade of his life, Rubens turned increasingly to portraits, genre scenes, and landscapes. These later works, such as *Landscape with the Château of Steen*, reflect a grand command of detail and staggering technical skill. His style is one of exuberance, with every element perfectly drawn and impeccably colored.

Diego Rodríguez de Silva y Velázquez, 1559–1660, Spanish
Las Meninas (The Handmaidens), 1656
Oil on canvas, 109 × 125 in (276 × 318 cm)
Prado, Madrid, Spain

I fell deeply in love with Diego Velázquez the first time I visited the Prado in the early sixties. I was, however, a bit let down by *Las Meninas*. I recognized it as a singularly sympathetic combination of illusion, reality, dream, and artful visual deceit. But it seemed muted by a film of whitish clouds. Years later those clouds—the varnish had "bloomed"—were dispersed by the brilliant conservator John Brealey, an Englishman I had hired at the Metropolitan and who was called upon by Spain to restore the country's finest masterpiece. My admiration for the painter grew in 1971, when I had the luck of winning at auction (for a then-world-record price) his *Juan de Pareja*, a sympathetic, hyperreal portrait of his chief assistant.

Born in Seville, Velázquez was quickly recognized as a child prodigy. At ten he was apprenticed to the Mannerist Francisco Pacheco, whose daughter he would eventually marry. Early on he produced intensely realistic studies of peasants. In 1622, a year after Philip IV was crowned, Velázquez sealed his career with his portrait of the king. He was appointed court painter and became a royal fixture and to some degree a member of the family. He was given his own studio and gallery in the palace itself, a unique honor. The king haunted it.

Velázquez visited Italy twice. On his second trip, in 1650–51, in an attempt to advertise his genius and, in his own words, "to limber my fingers"—he painted his Moorish companion Juan de Pareja. A servant then carried the portrait around to the studios of the most renowned artists. The servant knocked on the door and held up the painting at his side. According to reports of the time, "No one knew whom to talk to—the man or the painting—or who would answer, the image was so lifelike." The word reached Pope Innocent X, and Velázquez landed an unbelievably prestigious commission that resulted in the penetrating portrait of the cold and calculating pope, now in Rome's Pamphili Gallery.

On his return from Italy, Velázquez was appointed palace chamberlain. In 1656, in his palace studio, he started on what may be his finest work, the monumental *Las Meninas*. In this painting we see Velázquez in his studio, whose walls are loaded with paintings, including Rubens's *Pallas and Arachne* and *Apollo and Marsyas* by Jacob Jordaens. Velázquez is accompanied by the Infanta Margarita, the daughter of Philip IV, a charming child and a favorite of the artist. (He painted her three times, once when she was just two, here at five, and again when she was eight.) Margarita's ladies-in-waiting, a house dwarf (the court of Spain habitually employed dwarfs as good luck charms) and a huge fuzzy dog are also present.

What is the painting's subject? Velázquez is painting the king and his second wife, Mariana of Austria. They can be seen reflected in a mirror in the background of the picture. In the "real" space of the background we also see a courtier who has just been with the royal couple walking up some stairs.

What is so gripping about this painting is the way Velázquez captures a series of joyful events and creates an intriguing visual drama. The way the canvas is painted is awe-inspiring—it glows with a subdued natural light. The details are splendid—the mirror in the background, the shimmering clothing, the dwarf, the mastiff, Velázquez's surprised and amused expression, and the minute touches of color on his palette.

Las Meninas has it all—pomp and dignity, tenderness and joy, the smile of a child, the tricks of an artist, and a sense of life unfolding.

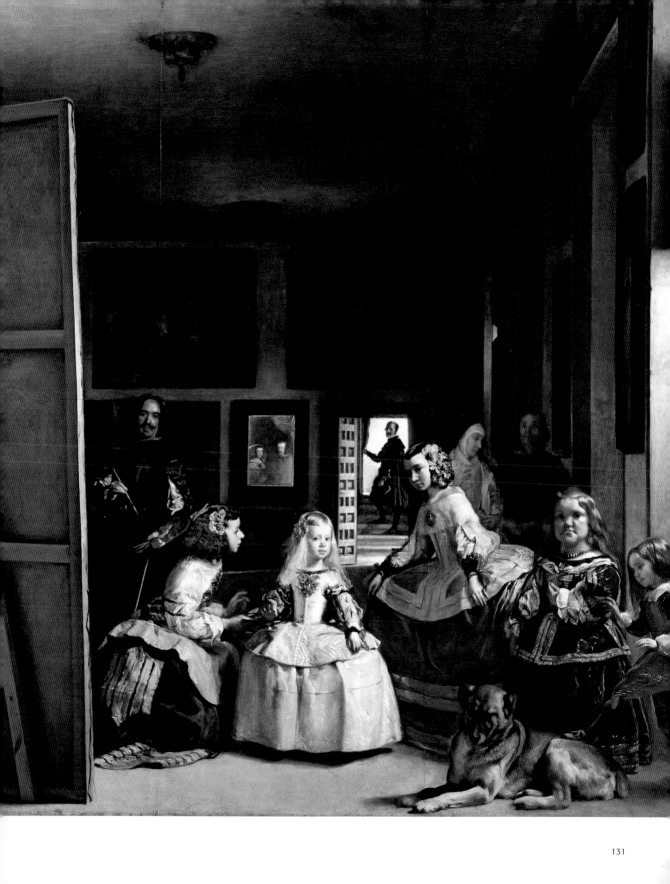

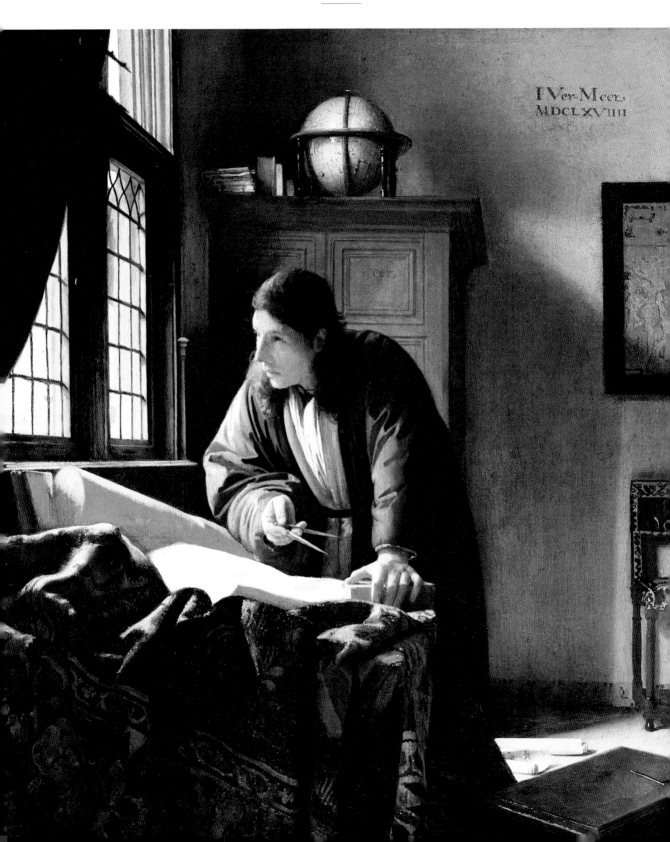

I Ver-Meer
MDCLXVIII

Jan Vermeer, 1632–75, Dutch

The Geographer, 1669
Oil on canvas, 21 × 18 in (53 × 47 cm)
Städelsches Kunstinstitut, Frankfurt, Germany

The Milkmaid, 1658–60
Oil on canvas, 18 × 16 in (46 × 40 cm)
Rijksmuseum, Amsterdam, The Netherlands

In 1968, when I was arranging a Masterpieces of Dresden blockbuster for the nation, I asked for Jan Vermeer's large, early *Procuress* but was told somewhat inexplicably that it was "unavailable." I finally saw it in the spring of 2004 in Jackson, Mississippi, as the star of another Dresden show, cleaned for the exhibit and magnificent.

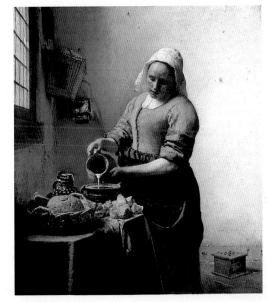

Vermeer, of whom very little is known, seems to have worked exclusively in Delft in Holland. Only slightly more than thirty-odd oil paintings by Vermeer have survived. Today he is considered one of the great painters in Western art, yet he was all but forgotten until he was rediscovered in 1866 by a French art critic.

Vermeer never titled his works. The painting at left has been named *The Geographer* for obvious reasons: the calipers, the globe atop the cupboard, the map case on the bench, and the map on the wall. Just above that wall map is the artist's "signature," *I* (for *Ian: I* and *J* were interchangeable back then) *Vermeer*, with the date 1668 in Roman numerals.

In this painting the male figure is endowed with a captivating energy, unlike the languid expressions of the women in many of his works. Vermeer's paintings are personal and contemplative. There is only a hint of a narrative, a silent drama, and we, the viewers, are left to invent the story of the painting ourselves.

One of Vermeer's stylistic signatures is light. In this painting it pours through the window on the left through thick panes of glass. Light and shadow and the effect of light on objects were an obsession for Vermeer. It's intriguing to track the light to everything in the room, from the thoughtful face of the young geographer to his snow white shirt, to the gleam on the varnished globe and to the highlights and the deep shadows of the marvelously painted carpet spread on the worktable. I find especially delicious those passages where Vermeer uses tiny gobs of pure white to enliven a splash of reflected light.

In *The Milkmaid*, Vermeer captures a single moment of a household chore. There is a strength in the young woman's concentration and the soft, well-worn look of her costume gives us an insight into her life. In this mundane moment there is a lovely sense of dignity and grace.

To me the accepted works of Vermeer rival the best of Rembrandt. His mysterious paintings possess an uncanny and unique universality.

Canaletto (Giovanni Antonio Canal), Italian,1697–1768
The Molo from the Bacino di San Marco, Venice, 1748
Oil on canvas, 33 ⅝ × 52 ⅞ in (85.5 × 134.2 cm)
San Diego Museum of Fine Arts, San Diego, California

Every time I see a great Canaletto—like this one, donated by Anne and Amy Putnam to the San Diego Museum of Fine Arts—I am instantly reminded of the glories of my personal Venice. I remember the time I spent one New Year's going from one grand costume party to another in a semideserted city; the winter daylight looked as if it had been filtered through silver mesh. Another time I rented a small working boat and spent three days navigating every canal (there are many more than you'd think, lots of traffic lights, and excellent "unknown" restaurants awash in *prosecco,* Venice's fine bubbly). And I once

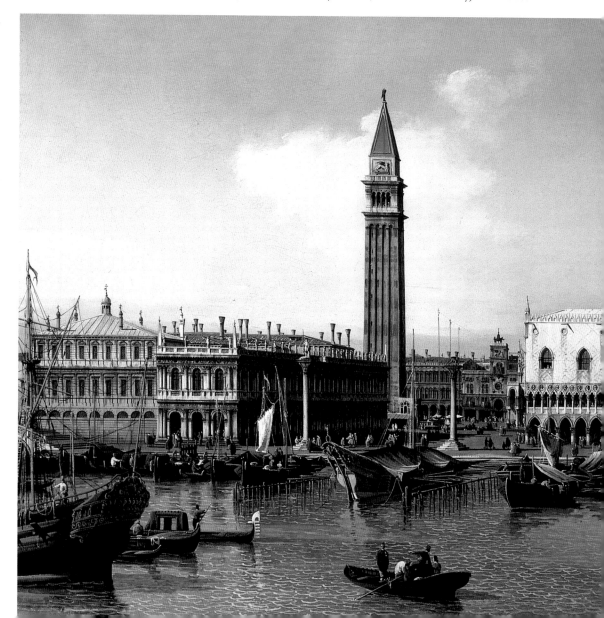

spent three days just on Titian, another two on Tiepolo, and a final four on Vittore Carpaccio. I am sure that Canaletto's contemporary patrons, most of them English, had the same reaction to his paintings. They are brilliant triggers for one's memory of the enchanted place.

Canaletto—and I mean Giovanni Antonio Canal, not his father Bernardo, or his nephew Bernardo Bellotto, who were also called "Canaletto"—was much more than an upscale postcard maker. His incomparable views of Venice are neither reality nor idealization;

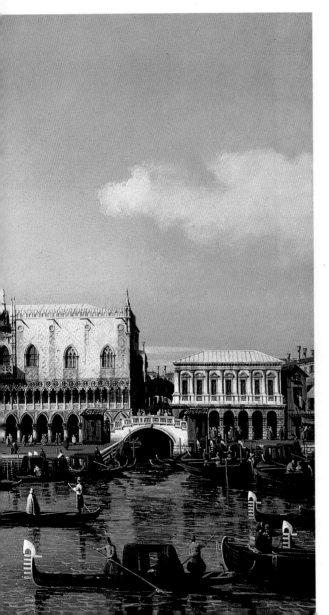

they are neither painstaking recreations nor pure inventions. You might call them divine revitalizations, not true Venice but the truly perfect Venice. His faithful rendering of the light unique to the city and his habit of reducing architecture to the essential give his works a special quality. He often painted from high above the scene, as in this picture. He also frequently used several rules of perspective in the same painting and, on occasion, used the camera obscura to help him get the details down accurately.

In this painting it's as if Canaletto were suspended in a hot-air balloon to better render the peaceful view of the Bacino, the Doge's Palace, the skyscraper bell tower, the busy Molo itself, and the gondolas unique to the city. The light is that of late summer, and the feeling is one of surpassing tranquillity.

Canaletto began by painting theatrical scenery (his father's profession) and turned to topography during a visit to Rome in 1719–20, when he was strongly influenced by the work of Giovanni Paolo Pannini. By 1723, back in Venice, he was painting dramatic and picturesque views of his hometown, known as La Serenissima, marked by strong contrasts of light and shade. In the 1730s, perhaps at the urging of Canaletto's principal patron, Joseph Smith, a merchant and British consul in Venice, Canaletto's most famous and exact views of Venice were engraved by Antonio Visentini and published in a volume that sold throughout Europe and England. Canaletto's fame was assured.

In 1746, after the War of the Austrian Succession had drastically curtailed foreign travel and the tourist trade in Venice had dried up, he went to England. There he painted a succession of stately homes and royal castles. Joseph Smith sold his great collection of Canalettos to George III, thus bringing into the royal collection an unrivaled group of his paintings and drawings. In 1755 Canaletto returned to Venice, where he continued painting for the remainder of his life, the sun always shining and the wind at his back.

William Hogarth, 1697–1764, English
Marriage à la Mode: The Tête-à-Tête (plate 2), ca. 1743
Oil on canvas, 27¹/₂ × 35³/₄ in (70.5 × 90.8 cm)
National Gallery, London, England

William Hogarth was a gifted engraver who could retain in his mind "without drawing on the spot whatever I wanted to imitate." He apprenticed as a silver engraver but was mostly self-taught. In the 1730s Hogarth began to paint series that satirized both the fashionable and down-and-out worlds of teeming London. (He was well-acquainted with the down-and-out: His father, a teacher, ended up in debtor's prison after a failed attempt at the restaurant business.) Hogarth called these artworks "modern moral subjects." They depicted bawdiness, drunkenness, gluttony, chicanery, and degradation, and naturally people loved them. They have a bite even today.

One of the best series is *Marriage à la Mode*, a group of seven splendidly cruel episodes in the decadent history of an arranged marriage between a dissolute, poverty-stricken young lord—heir to the distinguished title "Count Squanderfield"—and the daughter of a wealthy merchant. This painting shows the wrecked count, hungover after an all-nighter with his sword in a limp scabbard on the floor. His wife looks at him slyly for she, too, has been up all night, ostensibly playing cards with her "teacher." The anguished family accountant exits stage left.

If you want an accurate image of a nouveau-riche London home of the early eighteenth century, this is it. Boring old masters of unknown saints hang on the dining room walls. A horrid painting with a *putto* playing a pipe hangs over the mantelpiece. On it can be seen a particularly graceless antique head with a poorly restored nose. One look at this penetrating satire and you guess the outcome: the count run through by the wife's lover, and the suicide of the destitute countess.

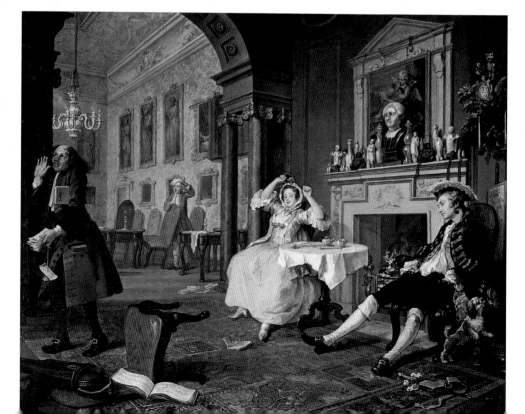

Thomas Gainsborough, 1727–88, English
The Blue Boy, ca. 1770
Oil on canvas, 70⅝ × 48¾ in (179.4 × 123.8 cm)
Huntington Library, San Marino, California

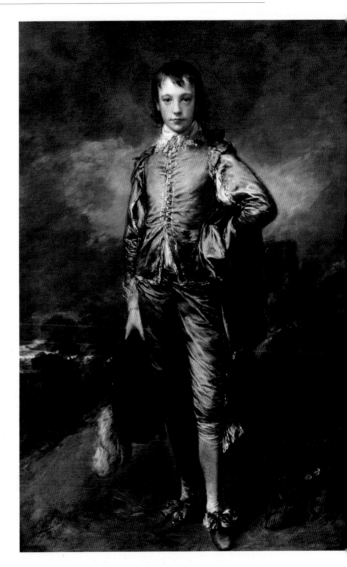

Thomas Gainsborough, one of the finest portrait painters in the history of England (a country known for stunning portraits), was aware of his life's goal at a young age. At thirteen he begged and received permission from his father (a wool merchant) to go to London to study painting—and a legend was born.

One of Gainsborough's most lustrous efforts—but by no means his sole masterpiece in a long and spectacular career—is the celebrated *Blue Boy*, the portrait of the young Jonathan Buttall, son of an Ipswich hardware merchant who was a close friend of the artist. The image is extraordinary in every way—from artistic daring to psychological acuity. It is an uncanny combination of direct realism and soft romanticism culminating in a poetic vision of the most melodic sort. Even the intense overreproduction of this work has not spoiled its freshness and calculated charm.

The striking costume seems more seventeenth than eighteenth century and may hark back to the time of Anthony van Dyck. The British have loved Van Dyck since he became Charles I's favorite, and Gainsborough was profoundly influenced by his style. This is, for sure, not merely some dandified clotheshorse; Jonathan is an alert, amusing young man. This face is presented straight on like an ancient Roman portrait, and he stands, arms set dramatically akimbo, in a pose far more classical in origin than Van Dyck would ever have conceived. How intense and, at the same time, how relaxed he seems!

Some of the details are sensational, especially the plume of the black velvet hat, the frilly stock, and those splendid silk buttons. The treatment of the landscape, with the burgeoning storm clouds and the vivid sunset, is equal to the magical handling of paint in the compellingly iridescent blue costume with its contrasting silver piping. The magical blue of the work is one of the more invigorating passages of paint in the entire eighteenth century.

Francisco Jose de Goya y Lucientes, 1746–1828, Spanish

Don Manuel Osorio Manrique de Zuñiga, 1784–92,
Oil on canvas, 50 × 40 in (127 × 101.6 cm)
The Metropolitan Museum of Art, New York, N.Y.

The Third of May, 1808, 1814
Oil on canvas, 105 × 156 in (266 × 395 cm)
Prado, Madrid, Spain

No other artist in Western civilization equals Francisco Goya's breadth and variety, not even Michelangelo or Picasso. His works, depending on the subject and the date of their composition, are entertaining, deeply spiritual, frivolous, lofty, brutal, lyrical, poignant, and tender. He is the quintessential timeless creator with one foot in all of antiquity and the other in our future. Goya lived a long life and died in France at the age of eighty-two.

Goya is notable for having a sweet as well as a dark side: He was capable of creating charming "cartoons" for decorative tapestries, the most prettified portraits, and explicitly cruel scenes of terror.

The light and prettified works are nicely summed up by *Don Manuel Osorio.* Who wouldn't want this well-dressed imp for a son or grandson? The face that looks out steadfastly at the viewer is endearing if slightly bland. We presume the stiff positioning of the face was a demand of the family that commissioned the portrait.

Goya has typically added a zest of drama and mystery to the image. The boy's pet bird—on a leash—is pecking obliviously at suet while three cats prepare to pounce. The cats are flocked on one side of the painting and on the other side is a cage bursting with birds.

Goya's brushwork is miraculous. Look at the satin sash and elaborate bow that serve as the visual center of the picture.

Does the boy want his bird to die? Is he disturbed? Or is he clueless? Knowing Goya, the boy is probably something of a little monster.

◆◆◆

Only Goya could have dreamed up the greatest monument in Western art devoted to horror, *The Third of May.*

We witness a massacre of poor souls who were part of a peoples' uprising in Madrid on May 3, 1808. Seven Napoleonic soldiers gun down a group of citizens one by one in the harsh glare of a large cubic lantern. The soldiers wear their packs, a detail revealing their desire to depart as soon as the slaughter is over.

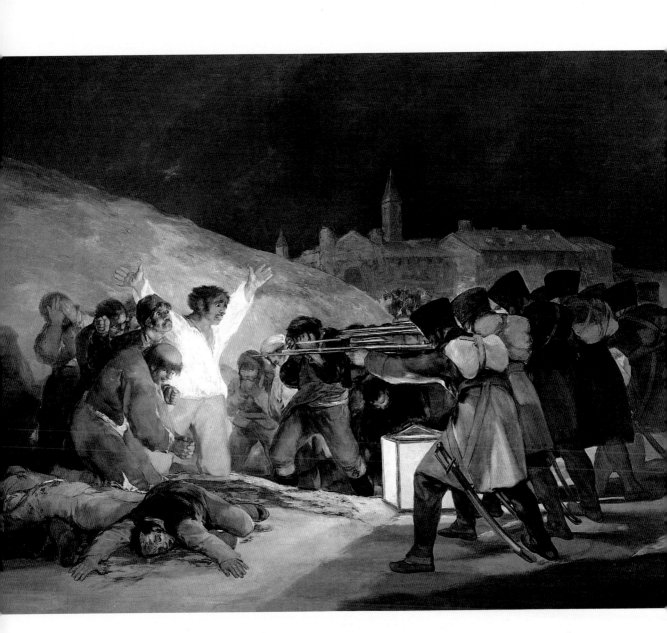

There is no hope; the victims are not going to be saved. Three are spread out on a carpet of gore while six more await their gruesome fate. The man in the center, resembling Christ on the cross, throws up his arms in an expression of horror and disbelief. A monk nearby prays, but his faith won't release him from his appointment with death. Others try to hide behind their hands; we know they will be killed. In the distance a crowd of witnesses and a part of Madrid are visible.

The painting presents a single incident of organized human brutality, a specific historical event. But Goy a transformed it and now this incident stands for all injustice. The painting has become an indelible and lasting symbol of every war atrocity, every act of genocide ever committed.

John Constable, 1776–1837, English
Wivenhoe Park, Essex, 1816
Oil on canvas, 22 1/8 × 39 7/8 in (56.1 × 101.2 cm)
National Gallery of Art, Washington, D.C.

The Impressionists are often given sole credit for recreating the true light of the outdoors on their sunny canvasses. Certain earlier artists were equally fascinated by the effects of natural light in landscapes and they achieved astonishing verisimilitude of nature.

The English genius of landscape John Constable was such an artist. Though he'd shown early promise

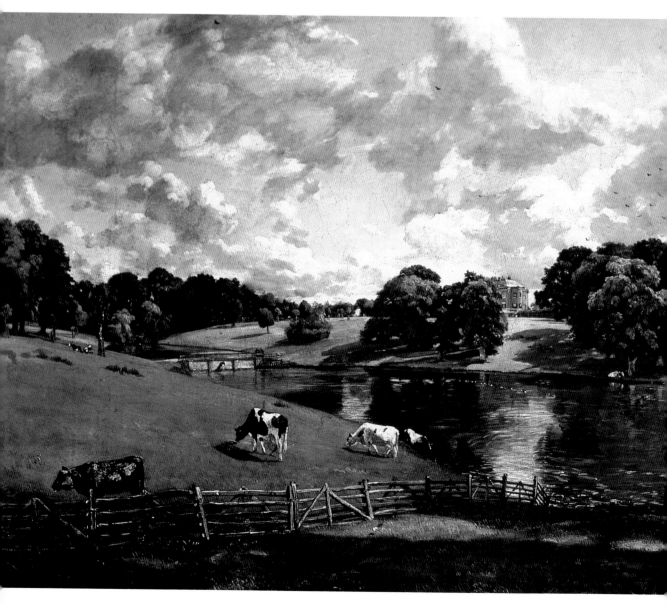

as an artist, Constable joined his wealthy family's flour business. After a year, at age twenty-three, he convinced his family to send him to art school. Joseph Mallord William Turner was also a student, and he has received most of the acclaim. Constable is rarely considered to be an exciting or groundbreaking painter. But he had a vision—to recreate the beauty of the Stour Valley, where he was raised. He developed his own way of painting to achieve this goal, rejecting the "picturesque" style of Gainsborough and other popular artists and concentrating on depicting nature accurately.

One of the most pleasing landscapes in Western art is Constable's view of the stately home Wivenhoe Park. We gaze down on the peaceful country estate on a spectacular day: The owners of the brick mansion are seen in a small carriage pulled by a donkey. A pair of fishermen, one in a crimson vest, are working nets in a small boat near a pair of swans. Their cohorts are onshore helping to haul. Four cows, several swans, and nine families of ducks amble on the ground as forty-eight blackbirds career in the sky. The sun-dappled waters are fully impressionistic.

Constable painted in a dark studio, slaving away at details by the light of an oil lamp and candles after having made quick oil sketches outdoors. He recorded specific cloud formations and the exact color of the sky and the leaves on the trees. Constable was a firm believer in the benefits of serious study and hard work; art, according to him, didn't come easily. He carefully studied the effects of light and the details of nature, poring over meteorological essays so that clouds, sun, and shade would be accurately depicted. In a lecture at the Royal Institution of Great Britain, he stated his philosophy of painting: " . . . in reality, what are the most sublime productions of the pencil but selections of some of the forms of nature, and copies of a few of her evanescent effects; and this is the result, not of inspiration, but of long and patient study, under the direction of much good sense. Painting is a science, and should be pursued as an inquiry into the laws of nature."

But his paintings don't seem like dispassionate scientific studies. In *Wivenhoe Park*, one would swear he'd set up his easel at the edge of that teeming pond and captured the whole sun-filled, shimmering scene *en plein air* in one placid, joyous morning.

Eugène Delacroix, 1798–1863, French
Liberty Leading the People, 1830
Oil on canvas, 102¼ × 128 in (260 × 325 cm)
Louvre, Paris, France

Eugène Delacroix was either the fourth child of
Charles Delacroix, a high government official, or the
illegitimate son of the diplomat Charles-Maurice de
Talleyrand-Périgord—whom he strongly resembled.
In 1822 his reputation was secured by a stunning
painting, *The Barque of Dante.* Two years later
Delacroix caused a sensation with his emotional
The Massacre at Chios, a personal outcry against
the Turkish massacres in Greece. He was proclaimed
the master of the Romantic movement, the polar
opposite of Ingres (see page 144), the ever-cool
classicist, who was less interested in dynamic color
and bold brushwork than in the perfection of drawing.

In 1825 Delacroix traveled to England and fell in
love with English Romantic literature; he devoured
the works of Sir Walter Scott and Byron. Later Delacroix
became obsessed with Arab subject matter, which let
his imagination soar into exotic and mysterious realms.

After the July revolution of 1830, Delacroix
produced the stirring *Liberty Leading the People,*
a virtual illustration of the disastrous revolution
depicted in Victor Hugo's sprawling *Les Misérables*
(it may have been the inspiration for the literary
masterwork). Liberty—or France (based on the *Winged
Victory* in the Louvre)—holds the tricolor proudly aloft
and leads the counterattack against Charles V's troops
from behind a barricade constructed of cobblestones
and timber. Three of the slain loyalist enemy are
visible in the foreground. A motley crew of citizens,
dressed in hats and sashes and carrying weapons
stripped from the fallen foe, surges forward.

Delacroix himself—seen here in a top hat—wrote to
his brother, "Since I have not fought and conquered
for the fatherland, I can at least paint on its behalf."

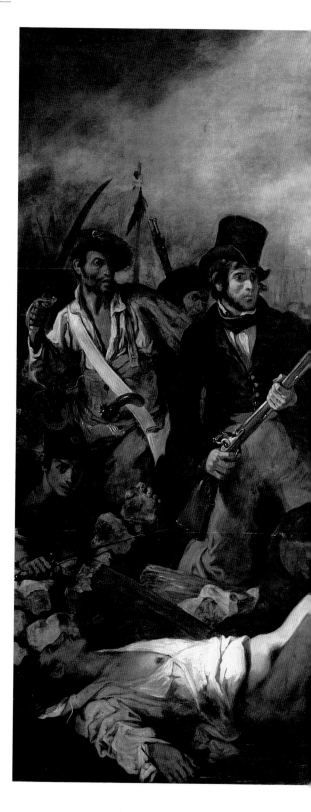

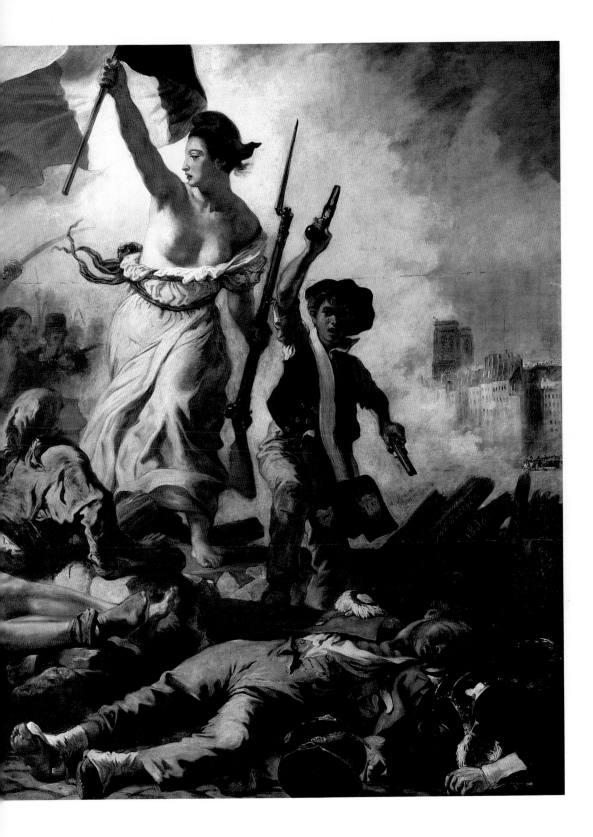

Jean-Auguste-Dominique Ingres, 1780–1867, French
The Turkish Bath, 1862
Oil on canvas on wood, 43¼ in diameter (110 cm)
Louvre, Paris, France

Art historians invariably find Jean-Auguste-Dominique Ingres to be a highly frustrating master. His large official commissions are undeniably dull, but his portraits, like the *Grand Odalisque* in the Louvre, and drawings are incomparably vital. Rarely has any portraitist equaled the purity of line and color Ingres achieved in self-portraits or the portrait of the Princesse de Broglie in New York's Metropolitan Museum. Virtually every drawing by Ingres exhibits an amazing power of perception and a sinuous line, on a par with the creations of Leonardo and Dürer.

At the age of eighty-three, this prim and proper Neoclassical star of the nineteenth century, known for his painstakingly smooth surfaces and his classically inspired or religious subject matter, painted an astonishingly sensual roundel entitled *The Turkish Bath* (also called *The Sultan's Harem*). It was highly controversial when it was shown, a voyeur's paradise through a keyhole into the enchanted and forbidden sanctuary of the sultan's coterie of gorgeous wives. On the surface it seems unlike Ingres. Yet, as his friend Charles Baudelaire pointed out, Ingres had a lifelong secret that explains *The Turkish Bath*.

Ingres was born in Montauban in the south of France in 1780, the son of a mediocre painter and sculptor. Starting in 1796 he studied in Paris with the paragon of the Neoclassical style, Jacques-Louis David, and won the prestigious Prix de Rome in 1801. His early subjects were his friends, himself, and a growing roster of wealthy clients. Ingres traveled to Rome in 1807 for the four-year stint that accompanied the Prix de Rome and continued to paint portraits while picking up several major commissions. One was a huge but lifeless painting

depicting the *Triumph of Romulus over Acron* for Napoleon's Roman palace.

After Rome, Ingres moved to Florence, where for four years he labored over *The Vow of Louis XIII*, a large religious painting destined for the cathedral in Montauban. It was displayed in the Paris Salon of 1824. Ingres was highly praised for the work and to his surprise was proclaimed by certain critics to be the leader of the much-favored opposition to the tumultuous Romantics led by Eugène Delacroix (see page 142) whose emotional painting *The Massacre of Chios* was exhibited in the same Salon.

After the unveiling of *The Massacre of Chios*, French painting was spoken of as two warring camps—the Neoclassicists and the Romantics. The former were lovers of pure line, muted colors, and dignified images; the latter were devoted to violent colors, turbulent brushstrokes, and highly emotional, even sexual, subjects. In short—Ingres versus Delacroix.

After his triumphal Salon exhibition of 1824, for the next decade Ingres remained in Paris, where he executed scintillating portraits and a huge work for Autun cathedral, *The Martyrdom of Saint Symphorian*. When this was attacked by the critics, Ingres returned to Rome, where he was appointed head of the prestigious French Academy.

Four years before his death Ingres painted *The Turkish Bath*. Most of the gorgeous European women (the skin of one Moorish wife contrasts strikingly with their white flesh) are nude; the few who are semiclothed appear just as naked. The variety of poses and links between the members of the harem are dramatic and daring. Some of the young wives relax, others appear bored. Some preen, others dance or, like the woman in the foreground,

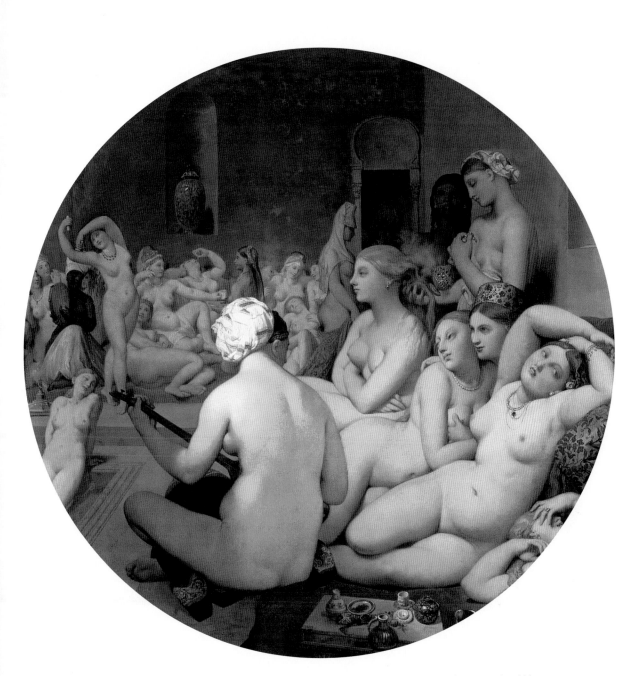

play the lute. One woman in the foreground fondles another absentmindedly. The work exhibits all of Ingres' trademark stylistic elements—perfect drawing, exquisitely subtle colors, and anatomy that is at times distorted for artistic effect. (Ingres was criticized for adding a vertebra to the impossibly long backs of his nudes.) The meticulously finished surface is pure

Ingres; he once remarked that paint should be as smooth as the skin of an onion.

How could Ingres have conceived of such a sexy image? When viewing *The Turkish Bath*, Baudelaire revealed that Ingres had been, for his whole life, "a man of a deeply sensuous nature."

In other words he was a closet Romantic.

Gustave Courbet, 1819–77, French
Sleep (The Two Friends), 1866
Oil on canvas, 53 $^1/_2$ × 78 $^1/_2$ in (93 × 278 cm)
Musée du Petit Palais, Paris, France

Gustave Courbet, the great French realist, started his career as a member of the stuffy Academy, which cranked out lifeless depictions of moments in history and mythology. In 1849, a year after the revolution of 1848, when he became a socialist and his lifelong passion for unvarnished realism was ignited, Courbet broke with the academy.

Courbet created a wide range of powerful works—landscapes, portraits, allegories, hunting scenes, and seascapes in which waves not only seem to crash physically on the beach but radiate light in ways that Impressionist paintings seldom equaled.

Obsessed with the real, Courbet was also much taken with the erotic, and he made many frankly sensual paintings that cause a stir even today. Luckily for him, one of his regular patrons, the Ottoman ambassador to France Khalil Bey, was a connoisseur of pornography. The result of one of Bey's commissions is this brightly colored, tightly painted work, which features a post-coital redhead and a blond sleeping after sex. The redhead is Flo, Whistler's favorite model. It is not difficult to read the work—it's an embrace of exhaustion after heated sexual passion. The lingering, loving embrace hints at further activity.

The picture is painted with bravura. Courbet lovingly presents the strikingly beautiful faces and bodies of the luscious pair and lingers over their luxuriant hair and sleep-drugged visages. The Turkish glass bottle and goblet that shine like beacons are also superbly painted. The vase of flowers could be a still-life painting on its own.

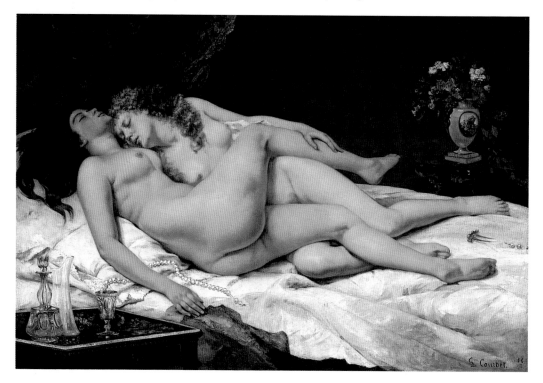

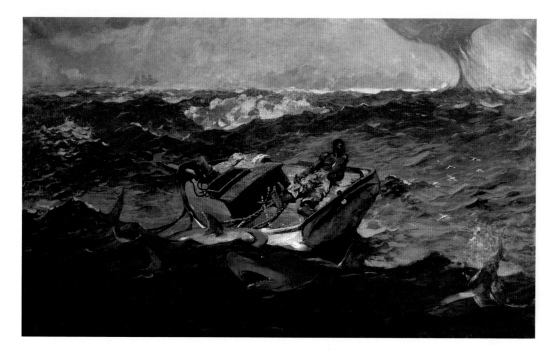

Winslow Homer, 1836–1910, American
The Gulf Stream, 1899
Oil on canvas, 28 1/8 × 49 1/8 in (71.4 × 124.8 cm)
The Metropolitan Museum of Art, New York, N.Y.

Winslow Homer was one of the most gifted—and popular—-American artists of the nineteenth century. Combining realism and theatricality, he depicted unforgettable scenes, starting with eyewitness sketches of the Civil War for *Harper's* magazine and ranging from daring rescues at sea to idyllic scenes of the Caribbean. *The Gulf Stream*, painted with Homer's unique bravura, illustrates a recurring theme in his work: man's relationship to nature.

We are in the Gulf Stream, as indicated by the emerald green seas, flying fish, and the strings of bloodred Sargasso weed floating in the waves; a waterspout swirls in the background. We can imagine what happened. A catboat skippered by a young black man transporting sugarcane has been dismasted in a storm. Rudderless, it has been sucked deep into the Gulf Stream, where sharks, smelling prey, circle patiently, waiting for the curtain to fall at the end of this sad drama. There's little hope for the young man. He's missed the three-masted schooner on the horizon, and he grasps a sugarcane stalk in the hope that he can suck just a little more water from it. Yet not all hope has disappeared. He's still in decent physical shape, and perhaps the next day or the one thereafter another ship will come close enough and rescue him. At least he's drifting close to a shipping lane. Maybe there's a flask of water belowdecks.

Alternatively another waterspout could smash into his damaged catboat and cast him to the sharks. This marvelous painting is so intriguing because the outcome could go either way.

Édouard Manet, 1832–83, French

Le Déjeuner sur L'Herbe, 1863
Oil on canvas, 84 × 106 in (230 × 262 cm)
Musée d'Orsay, Paris, France

A Bar at the Folies-Bergères, 1881–82
Oil on canvas, 36 × 60 in (90 × 150 cm)
Courtauld Institute Galleries, London, England

The clue to understanding Édouard Manet, especially in his innovative years of the 1860s, is to know that he spurned traditional, subtly graded modeling and boldly used flat expanses of gray, browns, and black. Unlike the academicians who used these hues only in shadows, Manet employed them as strong and vibrant tones, an effect that intensified his already bright colors.

In a sense Manet was the grandfather of Impressionism and the great-grandfather of Cubism. He is a man of many styles, ranging from his early dark paintings, heavily inspired by Velázquez, to airy, bright, fully impressionist works. Sometimes his works are very thinly painted; other times they are

made up of layer after layer of thick impasto, laid on as if with a trowel.

Art critics of his time attacked his works as shocking, graceless, and flat. Manet, who never exhibited with the Impressionists, was a bit of an outsider. His dream—to have his works hanging in the Louvre— never came true during his lifetime.

Even today the then-infamous *Le Déjeuner sur l'Herbe* has an edge, though not because of the flatness or lack of perspective that enraged contemporary critics. We are more intrigued by seeing two fully clothed gentlemen accompanied by two women, one naked, another almost so, at a picnic. What was Manet up to? I can't believe the

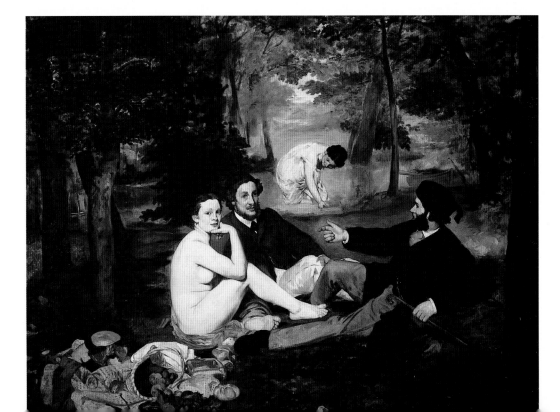

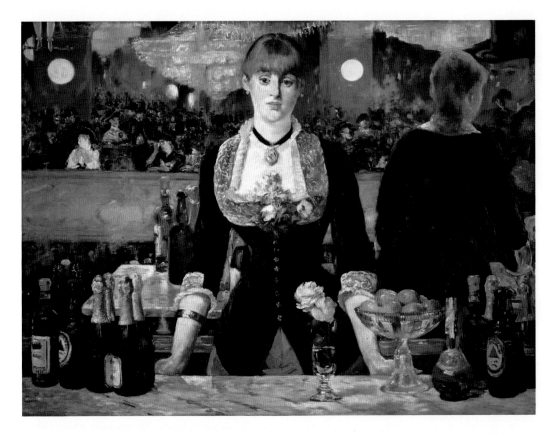

scene simply commemorates a memorable picnic. More likely he wanted to combine traditionalism with the modern Impressionist style. A clear piece of evidence is that this composition is derived in part from a late Renaissance print by Marcantonio Raimondi, after a composition by Raphael. The reclining man on the right is a close copy, except that here he is clothed.

Le Déjeuner glows with light and atmosphere. The details are memorable—especially the radiant still life of the woman's clothing, the basket, and the glistening silver brandy flask.

❖❖❖

In *A Bar at the Folies-Bergères*, Manet seems to have been searching for light, color, and spatial ambiguity. We, the viewers, are standing in line at the famous bar behind a gent who is about to ask Suzon, the barkeep, for a drink. Behind Suzon is a large mirror that reflects not only her back and her customer but the entire balcony of the Folies. Within the mirror we can see hosts of ladies and men, including some striking figures, many of whom are peering at each other through opera glasses. The main performance is lovingly detailed in the very upper left corner: the emerald shoes of a woman performer on a trapeze.

This bravura picture is all about reflection, color, shifting hues, and atmosphere. Using the mirror (which has bluish spots of fading mercury) to capture the essence of the music hall is much more compelling than painting the audience directly from a part of the balcony. All space becomes complicated, thrilling, and a bit mysterious. Manet delights in revealing his skills at still-life painting with the assorted bottles and a shimmering glass containing two roses.

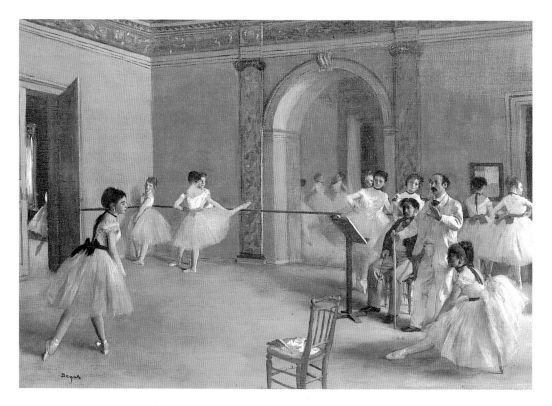

Hilaire-Germain-Edgar Degas, 1834–1917, French
The Dance Foyer at the Opéra, Rue Le Peletier, 1872
Oil on canvas, 13 × 18¹/₂ in (32 × 46 cm)
Musée D'Orsay, Paris, France

Degas adored painting women and was fascinated by the orchestra and the ballet. His ballet works focus on the agony of training and the constant ache of rehearsal, in which one step or one stretching movement was repeated hundreds of times.

This study, one of Degas' earliest dance paintings, shows dance master Louis François Merante and an Opéra subscriber watching a dancer rehearse in the chic Foyer at the Paris Opéra, which burned down in 1873. Dancers not only rehearsed in the Foyer, they also hung out there during intermissions; it was a place where it was socially acceptable for wealthy subscribers to mingle with half-naked teenagers.

Degas records every detail of the rehearsal, doting on the frilly ballet costumes of the youngsters. Uniting the disparate elements of this complex scene is an empty chair in the foreground piled with program notes. One imagines that Degas himself has just risen from that chair to record the scene.

Degas revered Ingres and studied with one of his pupils. He then attended the École des Beaux-Arts, and next went to Italy to study Renaissance art. His first works are portraits and historical subjects, done in a classical style. Later Degas met Manet and was influenced by the Impressionist revolution, especially its spontaneity and wide range of subjects.

A more dedicated draftsman than most of the Impressionists, he was often accused—rightly, I think—of being cold and detached, more interested in curves and lines than in people. Degas was aloof and bigoted, but a divine painter and later, when his eyesight began to fail, an even better sculptor.

Pierre-Auguste Renoir, 1841–1919, French
The Luncheon of the Boating Party, 1880–81
Oil on canvas, 54 × 68 in (130 × 173 cm)
The Phillips Collection, Washington, D.C.

If Impressionism had eyes, a mind, and a heart, Monet would be the eyes, Manet the brain, and Renoir the heart. His work, while exhibiting all the impressionist stylistic elements—fragmented, vivid color within a firm compositional structure—was emotional, sometimes sentimental, and almost always Romantic. He never imparts a doubt or a discouraging word.

It's fun to hang around the gallery where *The Luncheon of the Boating Party* hangs and watch the joyful expressions on the faces of people entering. We are on a restaurant veranda overlooking the Seine on a brilliant summer day, with a host of Renoir's friends who are having the time of their lives at a late luncheon where wine flows freely. The characters are exceptionally attractive, and you can be sure that the conversation is engaging and witty.

There's a lot of flirting going on, even a halfway serious conversation between two men in the upper right. One of the more delightful elements of this celebration of the good life is the young woman at the far left fluffing up her dog. Typical of Renoir, the dog can only be seen fully from a distance, where the Impressionistic "optical mixture" of brushstrokes comes into play.

This is not only a humanistic ode to fine French living but a gallery bursting with intriguing, impressionistic still lifes—the fruits, the wooden cask, and the napkins thrown on the table. The sun dapples this entertaining scene. Sensuous and effervescent, the picture sums up every felicitous moment of that blessed and all-too-brief period of peace and naïveté that existed in Paris before the coming of the twentieth century.

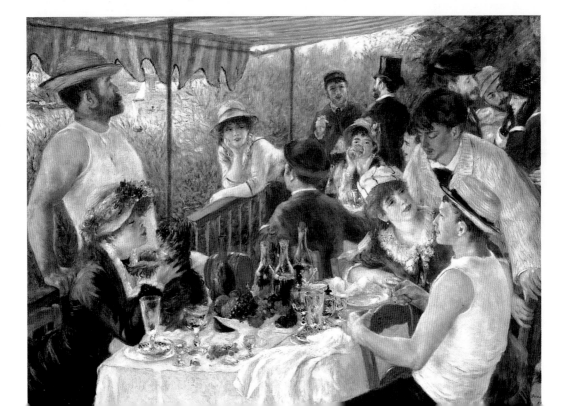

Paul Gauguin, 1840–1903, French
Where Do We Come From? What Are We? Where Are We Going?, 1897–98
Oil on canvas, 54 3/4 × 147 1/2 in (139.1 × 374.6 cm)
Museum of Fine Arts, Boston, Massachusetts

The greatest of the many mysteries cloaking the French genius Paul Gauguin is that he was entirely self-taught. How could he, without training, have created such compelling works—especially the late ones—that transcend those of his contemporaries? Perhaps it was because he was an aggressive, solipsistic man who set about creating his own artistic universe and succeeded.

Gauguin was born in Paris and died in the Marquesas Islands from the ravages of syphilis. After a brief stint at a brokerage firm in Paris, Gauguin came alive as an artist after he went to Tahiti. The bulk of his mature works were created in 1897, a year of intense turmoil for the troubled painter. These paintings combine Romanticism, symbolism, and high realism.

The best of this series is doubtless this huge canvas. Gauguin struggled greatly with the work, which he described as a furious creative assault during which he had become "a savage, a wolf let loose in the woods." The work looks as if it was done swiftly, without overpaints or changes. It is an explosive one-shot.

Gauguin intended the compellingly sensual work to be a suicide note that would "open up the minds of all

who gazed upon it." A week after he finished it, he took arsenic but survived. Gauguin left only one clue as to the work's subject. In a letter to a friend he stated that the essential part of the work is that which is not expressed. So, to understand the subject matter we should search for what has been left out.

Easy. When viewed from right to left, the painting clearly depicts the cycle of life. We see a young mother with her babe, then the fullness of life symbolized by the Tahitian reaching up to grab the fruit of life, and finally old age in the form of an elderly woman who holds her head in her hands in a gesture of despair. Death, the normal conclusion for the cycle, is not here. The real subject of the work is the inevitability of death—of the painter by suicide, and of all mankind.

Looking at this grandiose and placid picture it is hard to imagine the ferocity of Gauguin's labors or the profundity of the depression that gripped him at the time of its completion. Far from an assault or a dirge, it's pure pleasure. It's like plunging from a pink beach into the warm aquamarine surf of Tahiti. The colors are outrageously lush with incomparable shades of blue, green, pink, and yellow. Certain sections are unforgettable: the beautiful young man reaching for the pomegranate; the shimmering blue idol making the universal gesture of peace; the three young women protecting the baby; the pair of white cats behind the youngster eating an orange fruit; and the expressive old woman. Everything in this painting is unnatural yet essentially real. Gauguin's painterly genius has created a world of the mind that can never be, but which is, nonetheless, everlasting.

Edward Hicks, 1780–1849, American
The Peaceable Kingdom, ca. 1833
Oil on canvas, 24 × 31¼ in (60 × 78¼ cm)
Private Collection

Edward Hicks, America's quintessential folk painter, created more than a hundred versions of his famous *Peaceable Kingdom*. They are more subtle and sophisticated than they seem at first glance. Hicks may have been a self-taught artist, but he painted with exceptional confidence. Born in Pennsylvania, Hicks was orphaned as an infant and raised by a Quaker family. He returned to the Quaker faith after an illness, which is when he taught himself to paint.

This *Peaceable Kingdom* depicts the passage from the eleventh chapter of Isaiah, prophesying the coming of the Savior: "The wolf also shall dwell with the lamb, and the leopard shall lie down with the kid; and the calf and the young lion and fatling together; and a little child shall lead them." The message of peace appealed greatly to him. In this work settlers and Native Americans come together at the side of a calm lake while the beasts of the jungle congregate like good worshippers. The child Christ is in the center left with his arm and cloak around a giant tiger. A girl and a boy in the foreground play with the tusk of an elephant. I especially like the fierce wolf with his front legs crossed debonairly.

Hicks's drawing is solid and crisp, the colors vibrant. Decorative elements such as the curving horns of ox and bull are deftly delineated. This was an artist who could, one feels, walk up to a blackboard and draw an almost perfect circle.

Henri Rousseau, 1844–1910, French
The Dream, 1910
Oil on canvas, 80 1/2 × 117 1/2 in (204.5 × 298.5 cm)
The Museum of Modern Art, New York, N.Y.

Henri "Le Douanier" Rousseau was a self-taught painter whose works display the characteristics of many primitive painters: perfectly flat surfaces; minute detail; stiff, frontally posed figures with arbitrary proportions— just like ancient pictographs. At that days-long party during which Picasso revealed his revolutionary *Demoiselles d'Avignon* (see page 164) one of Rousseau's works was also on the studio wall. Picasso praised the artist as "the new realist, the last and greatest of the ancient Egyptian painters."

Though his works are not technically skilled, Rousseau's subject matter—such as a soccer team in striped jerseys or an exotic jungle with a bright-eyed tiger leaping through the vegetation—is uniquely dreamy and compelling. One of my favorite Rousseaus is *The Dream,* which, like all of his works, is thoroughly impossible, powerful, and unforgettable. A naked woman reclines on a bourgeois divan in the midst of a lush tropical jungle (she may be gesturing toward a flutist in a rainbow-colored bikini). The

woman seems utterly unaware of the elephant behind her and two tigers with agate eyes sneaking up on her from the brush. A giant red snake exits stage right. A full moon illuminates this bizarre scene. Sure, it's ridiculous, but it succeeds as the depiction of a heady dream. Rousseau can, I suppose, be looked upon as the granddaddy of many of the surrealists of the 1920s and 1930s. I suspect René Magritte might not have existed without him.

Rousseau was born into a family of modest means and was employed in 1885 as a customs inspector near Paris, where he picked up the nickname *Le Douanier* (customs officer). He started painting on his own in 1885, and took it up full time on retirement in 1893. His paintings, which he took to the Salon des Indépendents from 1886 until his death, were roundly mocked. But not by everyone. Even before Picasso, perceptive artists like Toulouse-Lautrec and Degas recognized Douanier's landmark contribution in moving art away from naturalism toward abstraction.

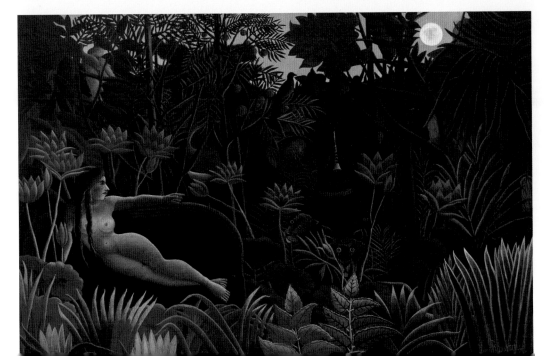

Marc Chagall, 1887–1985, Russian
The Juggler, 1943
Oil on canvas, 43¼ × 31⅛ in (109.9 × 79.1 cm)
The Art Institute of Chicago, Illinois

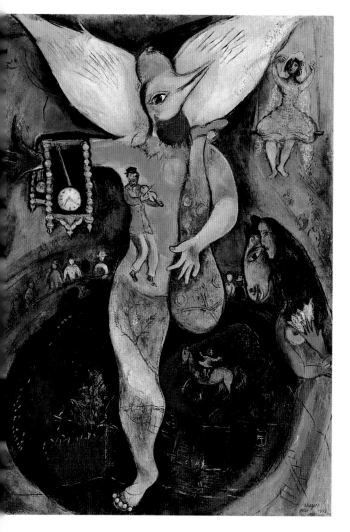

Charm and humor are not often found in great art, but the work of Marc Chagall is an exception. *The Juggler* is a picture of considerable artistic stature, and it also has surpassing charm and a sense of fun. How else to explain a bird with an emerald brush cut, dressed in a green jacket and a red bandanna, giving us a come-hither look and prancing like a Rockette on human legs clad in azure pantyhose?

The meaning is deeper than it might first appear, however: draped over his right arm this lively juggler carries a metronome, symbolizing music and dance as well as the dance of life and death. Chagall's signature image, a Russian Jewish fiddler, rests squarely on the right side of the bird. The colors of this beautiful work are powder greens, reds, blues, and silver yellows—all very typical of Marc Chagall.

Moses Zakharovich Shagal, or Marc Chagall as he is better known, was one of eight children of a Russian Jewish family in Vitebsk, Russia. Showing early artistic talent, he was sent to Saint Petersburg for training and subsequently to Paris. During the German occupation in World War II, he fled to New York at the invitation of The Museum of Modern Art and remained there until 1947, when he left for Paris, where he lived for the rest of his life. In his art he created an enchanting and dreamlike universe that combined elements of Fauvism, Cubism, Luminism, and Surrealism. His costumes and sets for Stravinsky's *Firebird Suite,* performed by the New York City Ballet, became the talk of the civilized world.

Chagall's range of media is protean—paintings, engravings, lithographs, murals (notably those in the lobby of New York's Metropolitan Opera House), and stained glass. Especially striking are his biblical illustrations. Chagall's unique artistic visions have been rightly likened to visual poetry. He peopled his pictures with angels, lovers, flying cows, circus performers, and roosters, creating elegies that proclaim the beauty of all creation. With an unwavering belief in the existence of miracles and in the infinite wisdom of God, Marc Chagall was an unreconstructed optimist, and he showed it with every brushstroke, every green, blue, or purple face, every kiss of his lovers, and every little house of Vitebsk.

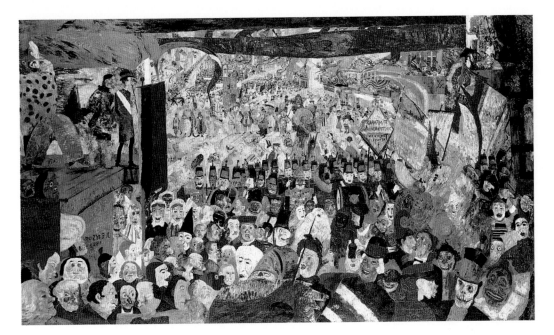

James Ensor, 1860–1949, Belgian
Christ's Triumphant Entry into Brussels in 1889, 1888
Oil on canvas, 99¹/₂ × 169¹/₂ in (249 × 425 cm)
J. Paul Getty Museum, Los Angeles, California

One of the glories of the Getty Museum is this chaotic painting, a strident outcry against capitalism that would have dismayed the museum's billionaire namesake. Trained as an academician, Ensor (whose father owned a souvenir shop filled with kitsch) turned against his schooling and virtually every other contemporary art movement. His unique style combines the ugly, the obscene, and the occult to produce images that were assaults against traditional notions of beauty. Ensor was obsessed with masks and skeletons (a reprise of *memento mori* images), which are portrayed alternately as ominous Halloween death symbols and as stand-up comedians. His palette varies widely, muted and earth-hued in some works and violent out-of-the-tube primaries in others.

Christ's Entry resembles a computer-generated crowd scene in a modern science-fiction film, but with infinite artistry. It shows Ensor as Christ (he thought he was Christ's alter ego) on the back of an ass, parading through town led by and surrounded by thousands of the citizens of Brussels. It's not just a ship of fools, the whole fleet is in. Every face (except for the tiniest) is an individualized caricature.

Ensor got on everyone's nerves. He was a founding member of an avant-garde society called Les XX. When *Entry* was presented to the group, his fellow members rejected it for being too scandalous. They were right. The work is jumbled and sends a muddled message.

After *The Entry* was rejected by Les XX, Ensor refused to show it publicly. Later his controversial works received full acceptance, and he was knighted. But Ensor's acceptance so calmed the revolutionary that his late works are soggy and passionless, lacking his trademark humor and irony.

Georges Seurat, 1859–91, French
A Sunday on La Grande Jatte, 1884–86
Oil on canvas, 81³/₄ × 121¹/₄ in (207.6 × 308 cm)
The Art Institute of Chicago, Illinois

My first of many encounters with the delightfully strange *Grande Jatte* was at the Museum of Modern Art in 1958. I was taken aback by the humanity and liveliness of what is essentially an abstract painting. I was also surprised that I wasn't distracted by a profusion of points of paint, which Seurat applied painstakingly to the canvas. When I stepped back to the proper distance, they all but disappeared. Imagine my horror upon hearing that a disastrous fire had destroyed a number of pictures in the show. The *Grande Jatte*—on loan from the Art Institute of Chicago for the first and only time in its history, per the terms of its bequest—was thankfully unharmed.

One of PostImpressionism's most widespread submovements was one that critics scorned as "Pointillism" and the artists of the style themselves called "Divisionism." Seurat was the grand master of Divisionism, and his unearthly, quirky canvases are the most subtle and enduring of them all.

Seurat enrolled in Paris's Municipal School of Design and haunted museums, where he copied old masters, especially Holbein and Raphael. But he was always as interested in science as in art, and he pored over the theoretical works of aestheticians concerning juxtapositions of forms and complementary colors. Seurat didn't often paint in actual dots or points, nor did his followers. They used short strokes of widely varying shapes ranging from dashes to curlicues to split dabs and the occasional inch-wide square or rectangle. Seurat was convinced that his colors would, at the proper distance, blend into a seamless atmospheric reality. He was right.

The *Grande Jatte* is perhaps the finest of Seurat's major works. He said, "The Panathenaeans of Phidias formed a procession. I want to make modern people, in their essential traits, move about as they do on those friezes." The work presents a panorama of people and their pets on a bustling summer Sunday on the small island in the river Seine. What is stunning is how successfully these "lathe-turned"

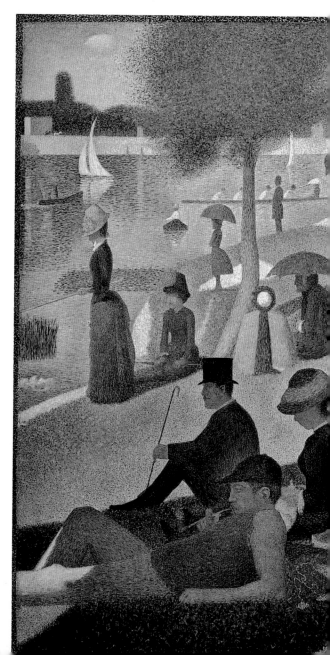

creatures have been captured, as if by an early photograph. The characters are fully realized: a man smoking a clay pipe is in the left foreground, a jumping dog and the monkey with his thin, curving tail are on the right, a man in a campaign hat plays a bugle near the left center of the cavalcade.

Seurat died suddenly at the age of thirty-one, having produced only seven major works. But for each of these, he made many surviving studies.

He was an avid draftsman, and his drawings, notable for their inky, velvet blacks, are instantly recognizable. For the *Grande Jatte*, he created twenty-three black sketches and thirty-eight different oil studies.

Today it is hard to imagine that most critics of the time attacked the painting. Seurat emerged unscathed for, luckily, the most influential critic of the day, Felix Feneon, gave the *Grande Jatte* the glowing review the masterwork deserved.

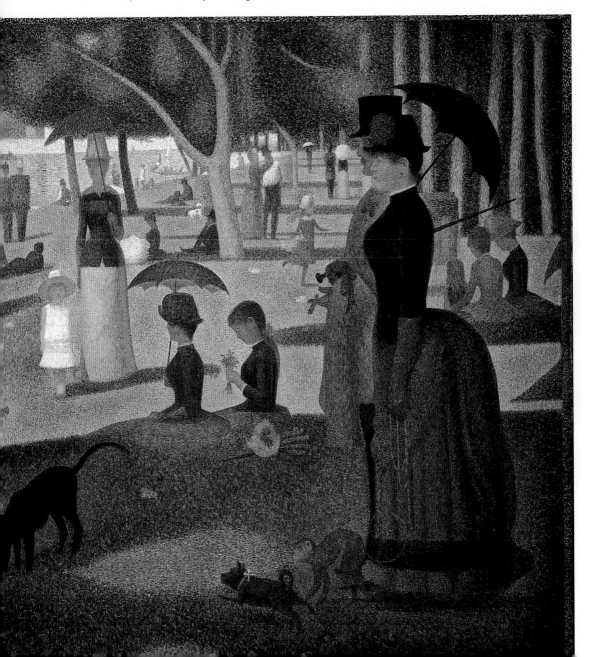

Vincent van Gogh, 1853–90, Dutch
Self-portrait, 1889
Oil on canvas, 26 × 22 in (65 × 54 cm)
Musée d'Orsay, Paris, France

Looking at this forthright self-portrait Vincent van Gogh painted almost a year before he killed himself, some say that signs of impending disaster are there. But I don't buy it. I see a look of I-will-make-it, not one of I-can't-take-it. Though there is an unmistakable unease in those penetrating eyes, strongly drawn with van Gogh's typical firm lines, and certainly his life was a turmoil (he had a form of epilepsy that would cripple him mentally), but nothing held him back artistically. Despite disappointments by the score, he ascended to the pinnacle of artistic accomplishment in his last years.

This portrait has many of van Gogh's hallmarks, the flamelike brushstrokes that curl and flicker like blue tongues of fire, and the stout drawing, so confident and unerring. Van Gogh's ear looks like a giant structure, as does the fiercely delineated left eye. Vincent's favorite color—the sunlike yellow—is missing here, but it's hidden in some of the strokes defining his hair. Van Gogh imparts to his face an all-encompassing humanity.

After dropping out of school at fifteen, van Gogh became an art dealer like his beloved younger brother, Theo. He went to London, became a teacher, visited old master galleries incessantly, fell in love with the Bible, and eventually tried to become a minister but failed the entrance exams for divinity school.

In Belgium he began to sketch miners and their families. In 1881 he tried art school in Brussels, hated the regimen, left, and largely taught himself. He got into oil paints in 1882, and by 1885—always in abject poverty—he created his early, dark paintings.

In 1886 van Gogh moved to Paris with Theo and soaked up Impressionism. Yet van Gogh always remained faithful to his own distinct personal style. He hated the rainy, gloomy winters of Paris and struck out for the South to establish an artists' commune. He rented the famous "Yellow House" in Arles, where he painted some of his most memorable works. Gauguin visited the "studio of the south," but the two artists clashed immediately (the famous ear amputation incident occurred shortly thereafter).

Van Gogh spent the next few years creating masterpieces that almost everyone spurned. His epilepsy worsened, and he was in and out of mental wards, but he always managed to return to painting and create another splendid canvas.

Van Gogh then moved to Auvers-sur-Oise, near Paris, where he seemed to improve. But on Sunday, July 27, 1890, he set out as usual for the fields. He took out a revolver and shot himself in the chest, whether by accident or intentionally will remain unknown.

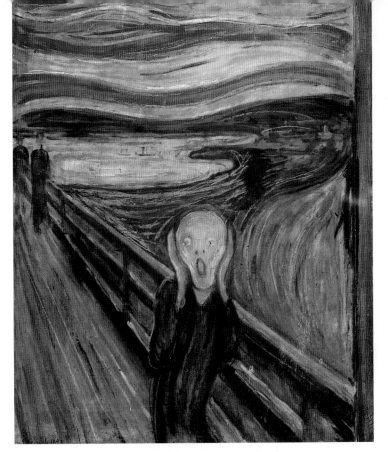

Edvard Munch, 1863–1944, Norwegian
The Scream, 1893
Casein/waxed crayon and tempera on cardboard, 35 7/8 × 29 in (91 × 73.5 cm)
National Gallery, Oslo, Norway

I have always looked upon Edvard Munch's fiery and horrifying *The Scream* as a nightmare. In this nightmare, a man—perhaps knowing that he's slowly losing his mind, as the artist himself indeed was—finds himself on a bridge in the throes of a primal terror.

Munch was Norway's most famous painter, lithographer, and wood engraver. His unsettling work was an outgrowth of his own unhappy life, marked by childhood tragedies, alcoholism, and passionate, destructive love affairs. Munch wrote in his diary that one evening while out walking with two friends, he looked back at the sunset and saw "tongues of fire above the blue black water." Terrified and trembling, he felt at that moment "an endless scream passing through nature."

In the painting nothing is clear, everything is awry. Are the two figures on the bridge ghosts hastening to grab the anguished human being? The swirling paint seems almost to suck the bald, shrieking figure into the abyss as he clutches his head in mental anguish. The sea is the color of what the sunset sky should be, and the land is the color of the sea. The only sense of calmness and order comes from the two sailing vessels anchored in those yellow waters.

In 1908 Munch suffered a devastating nervous breakdown and retired to a Danish nursing home. He recovered in 1910 and moved back to Norway, where he started painting again. His masterworks of this mature period are murals for the Festival Hall of the University of Oslo and some wildly and freely painted naturalistic landscapes.

John Singer Sargent, 1856–1925, American
The Daughters of Edward Darley Boit, 1882
Oil on canvas, 87⅜ × 87⅝ in (221.93 × 221.57 cm)
Museum of Fine Arts, Boston, Massachusetts

John Singer Sargent was one of the slickest portrait painters in the history of art—and by "slick" I mean accomplished. Working as a commissioned artist, he didn't hold much stock in his paintings, which he laughingly referred to as "paughtraits."

It is politically correct these days to deride Sargent as only "a performer in paint" (as the Impressionist Camille Pissarro put it) and an all-too-willing flatterer of British lords and ladies and American oligarchs, creating an apparently unending series of panegyrics in paint. But if you forget the buskins, the silks, the taffetas, and the superficial trappings to observe the people represented, you'll find wholly penetrating works. In addition to his portraits, Sargent created some breathtaking landscapes and scenes of the back streets of Venice. His World War I scene, *Gassed*, was judged one of the more powerful antiwar symbols of its day.

Sargent's father was an American doctor who moved to Europe for his wife's health. Sargent was born in Florence, and his mother, recognizing his early skill at drawing, encouraged him to capture in line or watercolor everything he saw. When he was in his early twenties, the Sargents moved to Paris, then the world capital of art. Sargent studied the old masters in the Louvre and met the Impressionists. His master, Émile-Auguste Carolus-Duran, was an accomplished portraitist, obsessed with Diego Velázquez. Carolus-Duran encouraged his students to paint directly on their canvases with loose brushstrokes and to develop variations of strong light and shade.

In 1878 Sargent won a second-class medal in the Salon and became so popular that he was able to establish a private studio and receive commissions.

In the Salon of 1879 Sargent made another splash by painting a dashing portrait of his dandified, narcissistic teacher.

After Sargent dared to present a "scandalous" work at the 1884 Paris Salon, his French career crashed. The painting was the notorious *Madame X*, a portrait of a twenty-three-year-old American, Virginie Gautreau—a daring social climber known for her flair for fashion and for her unearthly white and slightly violet skin, the product of a chalky, lavender powder she applied to her body (and perhaps also a result of arsenic). The portrait, now in the Metropolitan, horrified Parisian society not so much because of its ghostly pallor, but because it showed the bejeweled strap of Virginie's dress falling seductively off her shoulder. Even when Sargent repainted the strap anchored securely to her shoulder, the painting was vilified. With his commissions drying up, in 1886 Sargent left France and soon became the preeminent portrait painter to the rich and famous in Great Britain and America.

Before *Madame X*, in 1882, Sargent painted a bravura portrait of the four young daughters of a socialite Bostonian painter, Edward Darley Boit, who summered every year in Paris. The Boit portrait is an unconventional image by any stretch. One unimaginative critic of the time dismissed the work as "four corners and a void." To me it is full of magic and possesses a strange, satisfying mystery born from the mundane.

The somewhat ominous dark interior lit brilliantly from the left and accentuated by a harsh red dagger of drapery is probably inspired by both Vermeer and Veàzquez (see pages 132 and 130). Some observers

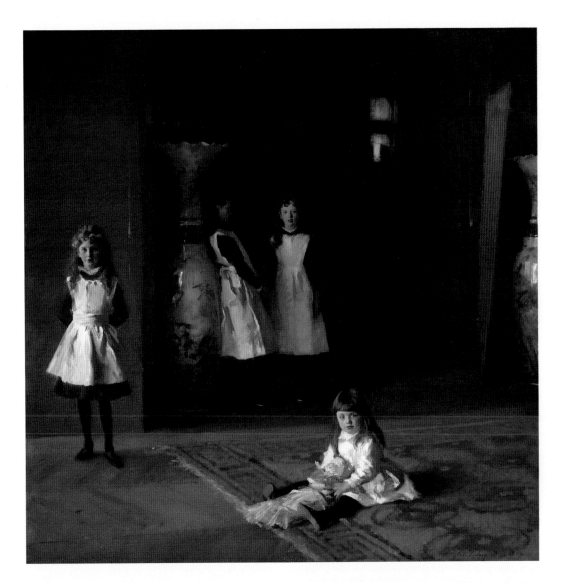

find in it a disconcerting sense of alienation and foreboding in the placement of the daughters (two of the quartet later had mental problems).

I see this painting as a celebration of the charms of the four delightful young women. Perhaps the eldest daughter leaning against the huge Japanese vase seems somewhat alienated, although she could simply be awkward and shy. She was a late-Victorian teenager, after all.

The two huge Japanese vases, which are painted as if they are members of the family, were transported between Boston and Paris sixteen times without damage. Later, they were donated to the Museum of Fine Arts, Boston by the family to accompany the painting.

Upon seeing this triumphant canvas, Henry James remarked, "Was the pinafore ever painted with such power and made so poetic?"

Pablo Picasso, 1881–1973, Spanish
Les Demoiselles d'Avignon, 1907
Oil on canvas, 96 × 92 in (243.9 × 233.7 cm)
The Museum of Modern Art, New York, N.Y.

In fifty centuries of art there have been relatively few single works that fundamentally changed the course of history. Giotto's Arena Chapel (page 97) is one; Pablo Picasso's *Les Demoiselles d'Avignon* is another. When Picasso revealed the painting at a party, his colleague Georges Braque said it appeared that Picasso had drunk gasoline and was spitting fire.

Demoiselles was and is a shock for its depiction of human figures—in this case five women of indeterminate age, possibly prostitutes in a Barcelona brothel, possibly African women at the side of a road—with radically distorted anatomies and facial features. This bold, somewhat frightening image of womanhood eventually progressed into Cubism.

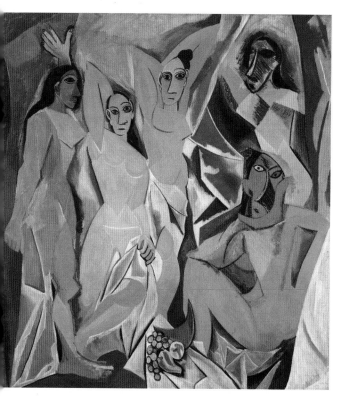

Picasso's ragged, inchoate canvas transformed the concept of beauty in art forever. Some of the faces are African masks, some are taken from pre-Roman Spanish sculpture. The bodies are torn asunder and rearranged in abstract forms. The colors are inhuman. The still life in the lower center of the canvas seems split apart and flattened. The blue and gray background drapery—if that is what it is—has been chopped into pieces. The result of this chaos and seemingly arbitrary dicing, slicing, and remaking is one of wondrous power.

Picasso was a child prodigy tutored mainly by his father, a drawing instructor (and art forger) who recognized surpassing genius in his son. Picasso's earliest works—realistic classical casts and bits and pieces of anatomy—are stunning. And in fact, Picasso was disdainful of subsequent generations who painted pure abstracts. When Picasso was fourteen his family moved from Malaga to avant-garde Barcelona, the Paris of Spain. Picasso studied briefly in Madrid but left school to study his beloved Goya and Velázquez and sketch people in the streets.

From 1902 to 1904 Picasso moved back and forth between Barcelona and Paris, painting castoffs, beggars, old drunks, and especially traveling circus performers. In 1907 the *Demoiselles* burst forth, and in the following year—inspired by the works of Paul Cézanne—Picasso and Georges Braque created the Cubist style. Cubism attempts to show multiple perspectives of a subject, whether a seated woman or a guitar, simultaneously.

Picasso invented a host of styles—Cubism, analytical Cubism, and synthetic Cubism. Picasso painted a series of penetrating propaganda works, the most effective of which is the monumental *Guernica*. None surpasses the nerve-shattering *Demoiselles d'Avignon*.

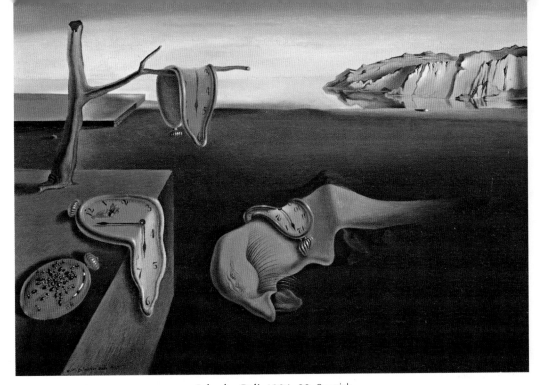

Salvador Dalí, 1904–89, Spanish
The Persistence of Memory, 1931
Oil on canvas, 9 1/2 × 13 in (24.1 × 33 cm)
The Museum of Modern Art, New York, N.Y.

I once had the pleasure of meeting Salvador Dalí in Paris at a café, where he sat in regal isolation, his mustache straight as cantilevers, wearing a faux-leopard smoking jacket, fondling a cane topped by a Rhino horn. We talked about whether his art would last. He was sure it would; I didn't agree with him. Today I've changed my mind. His works—even the PR stunts—will delight and mystify as long as they survive. Dalí was an incomparable trickster and magician of art, and there's a place in history for that.

He will probably not be remembered as a key member of the Surrealist movement—a broad, incohesive artistic movement of the 1920s through the 1940s that focused on dreams and pseudo-Freudian interpretations. As the years pass the confused message of Surrealism is losing its focus, but the images themselves burn brighter and brighter.

Dalí lived in Paris and New York for much of his life and ultimately retired to his surrealist lair in Catalonia. He was a garrulous, witty, publicity-hogging

eccentric. Early on he espoused Cubism of a sort but soon developed a unique and refreshing style of superrealism. He produced a prodigious number of dreamy landscapes and delightfully outlandish scenes filled with never-never land figures.

Dalí was the antithesis of Picasso. Both were violently Spanish, yet Picasso's works are mostly hard, Dalí's mostly soft; Picasso is worldwide, Dalí is local; his tiniest details are pure, lyrical Catalan.

One of the most unforgettable of his early works is *The Persistence of Memory*. Dalí breezily explained this painting to be "nothing more complicated than the tender, extravagant and arbitrary Camembert of time and space." What is the work supposed to mean? I am convinced that Dalí never intended us to learn. It is magical, incomprehensible to us common folk. That's why its appeal continues.

To me this radiant piece refers to those drowsy moments in life or dreams when time seems to be stuck in super-slow motion, literally slipping away.













GALLERY

Edward Hopper, 1882–1967, American

Early Sunday Morning, 1930
Oil on canvas, 35¼ × 60¼ in (88 × 150 cm)
Whitney Museum of American Art, New York, N. Y.

Nighthawks, 1942
Oil on canvas, 33 × 60 in (84.1 × 152.4 cm)
The Art Institute of Chicago, Illinois

Viewers tend to look upon Edward Hopper's works as having profound psychological import and an aura of loneliness. An American realist, Hopper transformed commonplace scenes into dramatic, klieg-lighted movie sets. His subject matter is strictly American: cityscapes, small-town architecture, gas stations, theaters, restaurants, and working people. Hopper insisted he was only interested in painting the light as it reflected off buildings or interiors.

Who can doubt him? Yet who does not stare at his gorgeous paintings and think, What has just happened and what's going to happen next?

Early Sunday Morning sums up the Great Depression. Although this Brooklyn landscape is mundane, it has all the poetry and mystery of an Egyptian temple frieze or a Western ghost town. Hopper delights in the contrasts of light and shadow and in rendering the various window shades and curtains. These brick buildings seem uninhabited just after dawn on a cold early spring day—why else are all the windows closed? Hopper often remarked that a mere detail could move him to do a work. One wonders if he was drawn to this scene by the shapes and colors of the barber pole and the fireplug.

Nighthawks, a later painting, is quintessential Hopper: lonely, brooding, and timeless. Supply your own story; here's mine: it's predawn in Washington, D.C., and the folks at the counter are having breakfast before going off to help in the war effort.

Although Hopper tended to generalize his subjects, he was a master of details, and his still lifes could be stunning, as is the cluster of chrome utensils or the coffee urns in *Nighthawks*.

Usually Hopper insisted that there was no hidden meaning to his paintings, but he did admit about this work that "unconsciously, probably, I was painting the loneliness of a large city."

166

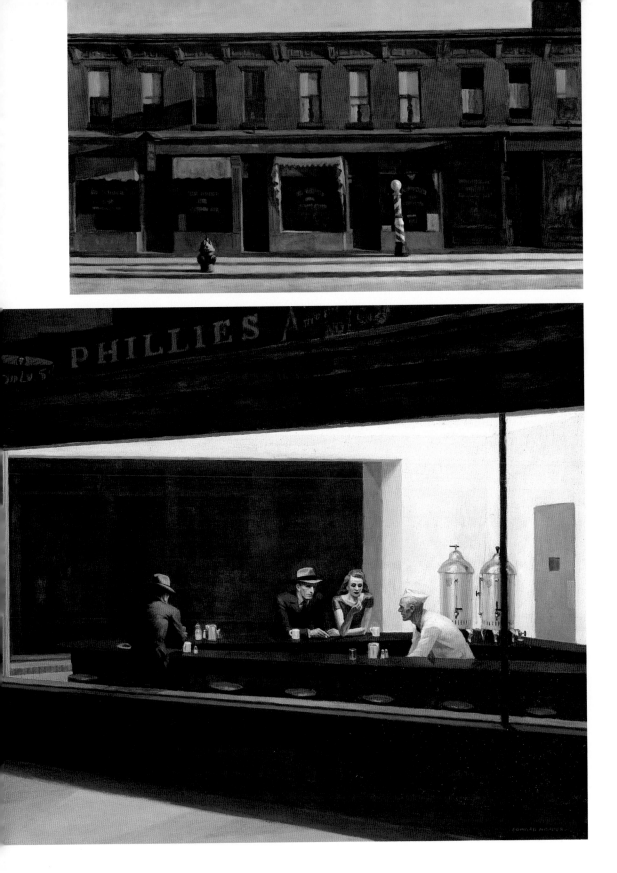

Norman Rockwell, 1894–1978, American
Saying Grace, 1951
Oil on canvas, 36 × 34¹/₄ in (91.4 × 87.1 cm)
Private Collection

When I was in graduate school, Norman Rockwell's homey images were the butt of many jokes, especially those of one extremely witty instructor. That instructor, now chief of exhibitions at New York's Guggenheim, made sure that a recent show of Rockwell's best works came to his museum, and he praised the works he used to cut to pieces. I, too, now realize that Rockwell is no joke; he's a great visual communicator, perhaps the best in American art.

For more than six decades, Rockwell delivered covers for the *Saturday Evening Post* portraying every aspect of American life. The subject matter of Rockwell's work was "we folks in America." Rockwell kept the time and place of each vignette

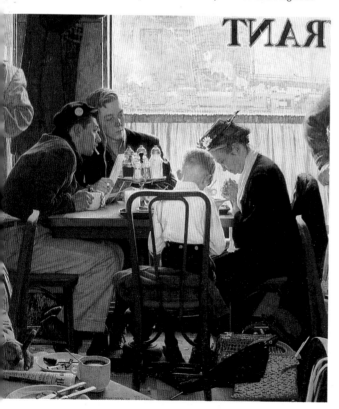

ambiguous so that individual viewers could supply their own stories about what was happening.

Saying Grace, hallmark Rockwell, is my favorite of all his works because of its intense human scrutiny. Rockwell's inspiration for the work came from a *Post* reader's letter that described a Mennonite family saying grace in a crowded Automat. The work captures the magical moment in an unkempt café near the railroad tracks in an unknown industrial town, when a grandmother and her grandson break the hubbub to observe grace. The onlookers' reactions are varied: Some are nonplussed; others are turned off; some are impressed. Rockwell's genius lay in giving a "photographic" view that wasn't stiffly two-dimensionally photographic at all. Atmosphere, temperature, and sound were vital to this artist. He wove his powerful impressions out of a series of magnificent details and sidebars, knowing that his fans doted on them. The scene outside the window is priceless—a sort of Japanese grisaille scroll depicting Big Industry. There's a fine ghostly portrait of a giant long-distance engine in front of a wooden water tank. Rockwell's eye for detail was exceptional: the cigarette hanging off a worker's lip (he wears a union badge), a plate with glittering knife and fork, ketchup oozing gummily down a bottle, Granny's alligator-patterned bag.

Rockwell was an avid student of art history. *Saying Grace* borrows from a Baroque master by balancing a striped lining with the fragment of the blue-and-white striped dress of the woman leaning forward and out of sight. The folds on the left arm of the raincoat on the man leaving with his umbrella could be out of *The Baptism* by Piero della Francesca (an artist Rockwell admired).

In August 1930 Grant Wood, a little-known Cedar Rapids interior decorator and painter, happened upon a small nineteenth century house designed in the simple style known as Carpenter Gothic, in Eldon, Iowa, decorated by a Gothic-arched window. The flimsy house with its amusing window gave him an idea: "I simply invented some American Gothic people to stand in front of a house of this type."

As models he picked his twenty-nine-year-old sister, Nan, and his dentist, B. H. McKeeby, whose long face had always intrigued him. He made a small sketch of the pair looking out expressionlessly with the house behind them. The man held a leaf rake, which was changed in the oil painting to a pitchfork. On the bottom Wood wrote, "American Gothic."

He submitted the work to the annual art show at the Art Institute of Chicago, where it received a prize of three hundred dollars. Critics loved it as much as the public did, and it soon became the icon for American fortitude, honesty, and righteousness.

Late Gothic Northern painting was one of Wood's sources. He adored Hans Memling. Amusingly, the "reflection" of the pitchfork in the farmer's faded overalls was inspired by Memling's *Adoration of the Virgin* in Munich's Alte Pinakothek, in which Saint Michael's shining armor reflects the Virgin and surrounding choir of angels.

In 1934 *Time* ran a story on Midwestern regionalist painters and praised Wood effusively, especially for standing up to such "awful" European styles as Cubism. The article made Wood an international celebrity. Even Gertrude Stein, Picasso's patron, gushed: "We should fear Grant Wood. . . . He is not only a satirical artist, but one who has a wonderful detachment from life in general—a necessity for creating the best of art."

Although Wood always maintained that *American Gothic* was not a harsh satire—just a mischievous one—viewers were and are divided pretty much down the middle on whether it praises eternal American virtues or spoofs them.

After Wood's death *American Gothic* fell out of favor. But in the late 1950s it surged back, primarily because it was used in political parodies and to advertise products ranging from beer to cornflakes.

Today it has become the most recognizable painting in the nation, a part of our consciousness and conscience.

Frida Kahlo, 1907–54, Mexican
Self-Portrait with Thorn Necklace and Hummingbird, 1940
Oil on canvas, 24 × 19 in (61 × 48.2 cm)
Harry Ransom Humanities Research Center, University of Texas, Austin

Frida Kahlo might not have become the cult figure she is today had it not been for the feminist movement, Hayden Herrera's brilliant book about her, or the recent film on her life. Kahlo's work is confrontational and eerie, a daring combination of observable truths and subliminal references. Strikingly individual, Kahlo's canvases are gutsy and universal depictions of pain.

Kahlo suffered physically all her short life and died at forty-seven. She contracted polio as a child,

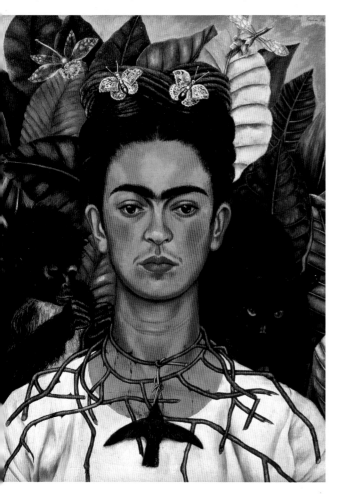

and at eighteen she was almost crushed to death in a bus accident. While she was recovering she met Diego Rivera, the internationally famed mural painter who was twenty years her senior. She became his lover and his wife. Their life together was tempestuous. Rivera was a philanderer, and Frida had torrid affairs of her own with men and women.

Of the 143 paintings she produced, 55 were self-portraits. Her style is part Diego Rivera, part "Le Douanier" Rousseau (see page 155) and part pre-Columbian art. Many of her paintings—which grow out of the Mexican Catholic tradition of presenting death and brutality—unflinchingly depict birth, death, sex, and violence. (Kahlo had a habit of spattering her frames with red to emphasize a work's bloody nature.) It is difficult to classify her work. She said, "I'm not a Surrealist. I never painted dreams. I painted my own reality. The only thing I know is that I paint because I need to, and I paint always whatever passes through my head, without any other considerations."

In this painting Kahlo uses the Mexican jungle landscape to form the lush, verdant backdrop for her face, which stares out stonily like a Byzantine icon of the Madonna. Her eyebrows are stark black crescents and there's the trace of a mustache over her full lips. The gnarled necklace of thorns refers to the suffering of Christ, while the dead hummingbird is a nod to the Aztec belief that the souls of brave warriors return to this world as hummingbirds. Kahlo often used the image of the monkey to signify sexual energy and vigor and the black cat as a witness to her suffering.

Kahlo once said that she'd suffered two grave accidents in her short life—the bus crash that almost killed her, and Diego Rivera.

Peter Blume, 1906–92, American
The Eternal City, 1937
Oil on composition board, 34 × 47⁷/₈ in (86.4 × 121.8 cm)
The Museum of Modern Art, New York, N.Y.

I started haunting the Museum of Modern Art when I was in my teens more to impress dates than to drink deeply of artistic springs. Yet, even with distractions, I was overwhelmed by legendary masterpieces like Picasso's *Guernica*, Cézannes, and Van Goghs—and by a singular painting called *The Eternal City* that was painted by Russian-born hyperrealist Peter Blume.

Blume immigrated to Brooklyn with his family in 1911. He took art lessons at a community center on the Lower East Side. He developed an icily realistic style peppered with literary and visual symbolism tinged with surrealism.

Blume burst upon the American art scene in 1931 by winning the prestigious Carnegie International Award. He lived in Rome from 1932 to 1934 and was in Rome on the tenth anniversary of Mussolini's Blackshirts' original march on Rome. He later crafted this stunning, symbolist-surrealist work condemning Fascism and the phony Mussolini reforms. In 1937

the painting was controversial; America was far from rejecting Fascism, and Mussolini was still grudgingly admired as the man who got the trains to run on time.

The painting is dominated by the threatening, poisonously green caricature of Il Duce. The view is from a rearranged Roman Forum set surreally in front of the Italian Alps. In the foreground are shattered fragments of ancient Roman sculpture. Below the monstrous scowling mask are catacomb-like foundations. Two lurking citizens seem to be in awe of the Duce. Behind the broken statuary is an old woman begging vainly. Blume's painting implies that although Mussolini has control, it won't last very long—he'll die of the green disease. Although the Fascist reign may seem to be as bright as the gorgeous evening, it is doomed to fall into the darkness of Rome. The city is eternal, its demagogues are not.

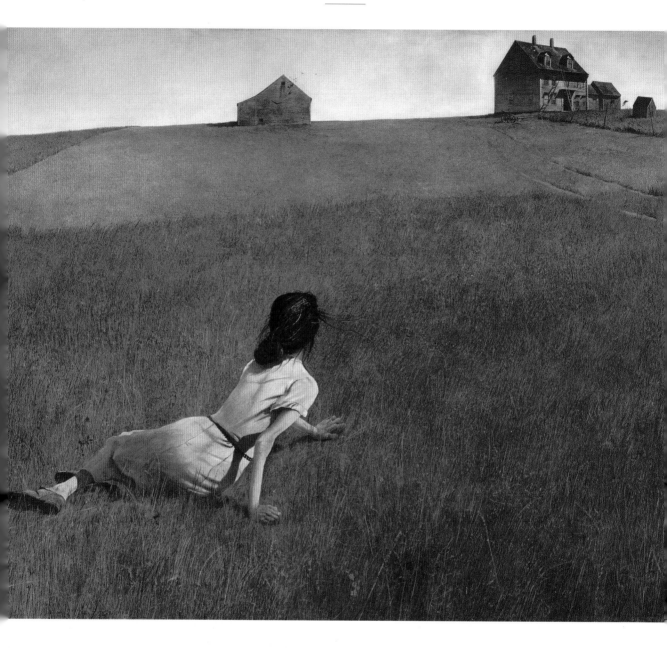

Andrew Wyeth, 1917– , American
Christina's World, 1948 (LEFT)
Tempera on gessoed panel, 32 1/4 × 47 3/4 in
(82 × 121.3 cm)
The Museum of Modern Art, New York, N.Y.

American realist Andrew Wyeth, the son of illustrator N. C. Wyeth, has seldom strayed from two homes: Chadds Ford, Pennsylvania, and Cushing, Maine. He started drawing at six, but his father wisely left him alone and started teaching him formally when he was fourteen. Wyeth learned drawing, watercolor, and eventually tempera, a difficult technique in which dry colors are mixed with egg yolk and which Wyeth describes as "similar to creating all the layers of the earth itself." He had his first show in New York when he was twenty, and though his watercolors sold out, he was unsatisfied and turned to the stark, muted colors of the Pennsylvania farm country and of Maine.

In Cushing he befriended lobsterman Alvaro Olson and his sister, Christina. He painted dozens of temperas, watercolors, and drybrushes of them. Some years ago Wyeth talked to me about *Christina's World*: "*Christina's World* is more than just her portrait. It was her whole life and what she liked in it. Funny, over the years people say to me, 'How beautiful young Christina is,' not realizing she was a sick, fragile old cripple!"

David Hockney, 1937– , British
Man in the Shower in Beverly Hills, 1964
Acrylic on canvas, 67 × 67 in (167.3 × 167 cm)
Tate Gallery, London, England

After traditional training at the Royal College of Art in London, David Hockney—who is one of the best-known British artists of our day—explored a variety of styles and media. After achieving early recognition with a style that combined realism with restrained abstraction, he visited America and liked it so much that he stayed. Later, Hockney became enchanted with Polaroid photography; he manipulated and converged images in photocollages that many consider his most interesting work. He also designed spectacular sets for opera and theater. *Man in the Shower in Beverly Hills* is typical of his fascination with the relaxed culture of southern California.

INDEX

ANSWER KEY

DETAIL	PAGE	ARTIST
1	108	Botticelli
2	131	Velasquez
3	166	Hopper
4	158	Seurat
5	157	Ensor
6	152	Gauguin
7	125	Caravaggio
8	112	Michelangelo
9	139	Goya
10	108	Botticelli
11	146	Courbet
12	142	Delacroix
13	148	Manet
14	119	Titian
15	145	Ingres
16	156	Chagall
17	150	Degas
18	148	Manet
19	106	Leonardo
20	106	Leonardo
21	170	Kahlo
22	169	Wood
23	131	Manet
24	137	Gainsborough
25	160	van Gogh
26	98	van Eyck
27	124	Caravaggio
28	98	van Eyck
29	136	Hogarth
30	165	Dali
31	136	Hogarth
32	156	Chagall
33	167	Hopper
34	151	Renoir
35	139	Goya
36	142	Delacroix
37	117	Bosch
38	111	Rapheal
39	106	Leonardo
40	169	Wood
41	133	Vermeer
42	124	Caravaggio
43	146	Courbet
44	145	Ingres
45	119	Titian
46	131	Manet
47	128	Rubens
48	173	Hockney
49	112	Michelangelo
50	123	El Greco
51	104	van der Goes
52	158	Seurat
53	162	Sargent
54	120	Brueghel, Pieter
55	117	Bosch
56	147	Homer
57	126	Brueghel, Jan
58	148	Manet
59	111	Raphael
60	131	Velazquez
61	150	Degas
62	163	Sargent
63	170	Kahlo
64	126	Brueghel, Jan
65	154	Hicks
66	155	Rousseau
67	107	Piero di Cosimo
68	147	Homer
69	151	Renoir
70	158	Seurat
71	132	Vermeer
72	168	Rockwell
73	166	Hopper
74	119	Titian
75	154	Hicks
76	104	van der Goes
77	109	Botticelli
78	140	Constable
79	126	Brueghel, Jan
80	111	Raphael
81	131	Velazquez
82	136	Hogarth
83	123	El Greco
84	97	Giotto
85	98	van Eyck
86	136	Hogarth
87	126	Brueghel, Jan
88	166	Hopper
89	151	Renoir
90	152	Gauguin
91	138	Goya
92	131	Velazquez
93	158	Seurat
94	170	Kahlo
95	115	Holbein
96	128	Rubens
97	155	Rousseau
98	126	Brueghel, Jan
99	149	Manet
100	104	van der Goes
101	146	Courbet
102	126	Brueghel, Jan
103	120	Brueghel, Pieter
104	102	Uccello
105	107	Piero di Cosimo
106	104	van der Goes
107	109	Botticelli
108	164	Picasso
109	115	Holbein
110	117	Bosch
111	117	Bosch
112	172	Wyeth
113	112	Michelangelo
114	168	Rockwell
115	145	Ingres
116	146	Courbet
117	124	Caravaggio
118	151	Renoir
119	104	van der Goes
120	104	van der Goes
121	136	Hogarth
122	111	Raphael
123	171	Blume
124	168	Rockwell
125	128	Rubens
126	97	Giotto
127	101	Fra Angelico
128	123	El Greco
129	125	Caravaggio
130	104	van der Goes
131	109	Botticelli
133	140	Constable
133	120	Brueghel, Pieter
134	148	Manet
135	154	Hicks
136	100	Fra Angelico
137	97	Giotto
138	107	Piero di Cosimo
139	101	Fra Angelico
140	107	Piero di Cosimo
141	150	Degas
142	120	Brueghel, Pieter
143	111	Raphael
144	134	Canaletto
145	117	Bosch
146	140	Constable
147	126	Brueghel, Jan
148	120	Brueghel, Pieter
149	139	Goya
150	104	van der Goes
151	172	Wyeth
152	139	Goya
153	171	Blume
154	98	van Eyck
155	169	Wood
156	132	Vermeer
157	166	Hopper
158	123	El Greco
159	119	Titian
160	132	Vermeer
161	98	van Eyck
162	155	Rousseau
163	108	Bottecelli
164	161	Munch
165	97	Giotto
166	145	Ingres
167	128	Rubens
168	160	van Gogh
169	123	El Greco
170	115	Holbein
171	102	Uccello
172	172	Wyeth
173	128	Rubens
174	123	El Greco
175	125	Caravaggio
176	119	Titian
177	142	Delacroix
178	108	Botticelli
179	148	Manet
180	97	Giotto
181	112	Michelangelo
182	134	Canaletto
183	117	Bosch
184	132	Vermeer
185	142	Delacroix
186	106	Leonardo
187	150	Degas
188	102	Uccello
189	115	Holbein
190	138	Goya
191	137	Gainsborough
192	151	Renoir
193	108	Botticello
194	133	Vermeer
195	98	van Eyck
196	142	Delacroix
197	123	El Greco
198	139	Goya
199	167	Hopper
200	155	Rousseau
201	102	Uccello
202	115	Holbein
203	128	Rubens
204	142	Delacroix
205	112	Michelangelo
206	97	Giotto
207	101	Fra Angelico
208	133	Vermeer
209	148	Manet
210	131	Velasquez
211	112	Michelangelo
212	132	Vermeer
213	128	Rubens
214	108	Botticelli

PHOTO CREDITS